HIGH PLAINS FARM

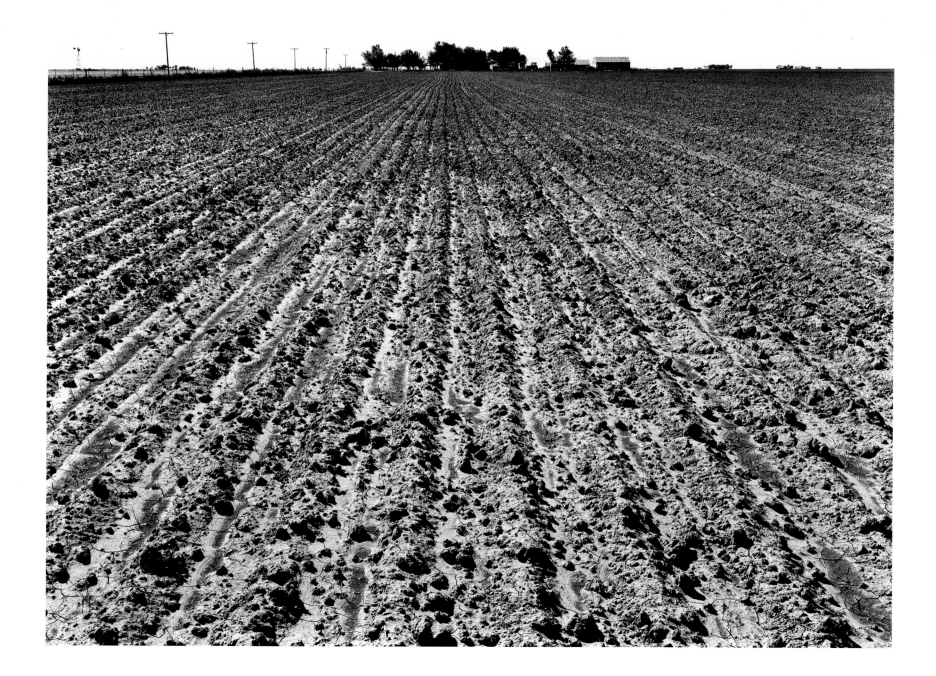

HIGH PLAINS FARM

Photographs and text by

PAULA CHAMLEE

Foreword by George F. Thompson

LODIMA PRESS
REVERE, PENNSYLVANIA

Published in cooperation with the
Center for American Places
Harrisonburg, Virginia

This book accompanies a traveling exhibition that opens at the
Amarillo Museum of Art

LIBRARY OF CONGRESS CATALOG CARD NUMBER: 96–075804

ISBN 0–9605646–8–3 (regular edition)
ISBN 0–9605646–9–1 (special edition)

PRINTED IN THE UNITED STATES OF AMERICA

To my parents

Lorin and Armenia Creitz

ACKNOWLEDGMENTS

When I began to photograph and to write about my family's farm, I had no clear thought of where it would lead me. Happily, the process—which has culminated in the making of this book—has led me to a wide range of people, organizations, and institutions that have not only helped make the work possible, but have also enriched my life greatly. To each of them I owe my deepest thanks.

I am grateful to Patrick McCracken, Director of the Amarillo Museum of Art. By responding to my photographs of the farm with support and enthusiasm from the beginning, and by scheduling an exhibition, he gave greater focus to my efforts.

My sincere thanks go to The Summerlee Foundation for its generous grant in support of my work, and to its director, John Crain, whose interest and positive response early on provided encouragement as well as valuable assistance in my making further trips to the Panhandle to work on the project.

I owe special thanks to the Texas Historical Foundation for support that came at a crucial time. I am particularly grateful to Julie Klump, its Executive Director, and to William P. Wright, Jr., who enthusiastically presented my work to the Foundation's board of directors.

I am indebted to Dr. Frederick W. Rathjen, historian and author of *The Texas Panhandle Frontier*. Through his scholarly writings, I have been guided and inspired. They have provided a valuable source that has formed the basis of much of my own writing about Panhandle history.

My thanks go to my assistants: to Filip Skalak, whose devoted help was manifested daily as he walked two miles each way through the fields to and from the studio in the waist-high snows of an unrelenting winter, and whose sense of humor added much pleasure to the months of printing; and to Erin Hiser, whose dedicated work and careful attention to detail, combined with her perpetually cheerful attitude, helped carry me through the long days in the darkroom during the final stages of the project.

I owe very special thanks to Richard Trenner, my brilliant editor, whose masterful skills combine knowledge and a sensitive eye and ear. Through his penchant for concision and clarity, he has helped bring my pages of notes, journal entries, and manuscript drafts into a cohesive form.

And last, my heartfelt thanks go to my husband, Michael A. Smith, my trusted advisor, sternest critic, and greatest inspiration. His insistence that I not put off a planned trip to my home place to begin photographing, at a time when other responsibilities were pressing, enabled me to get started when I was truly ready to begin. And his many suggestions regarding all aspects of this work, but especially the book and the form of my writings, have been invaluable.

PAULA CHAMLEE

FOREWORD

Each landscape that we visit and connect with carries with it an assembly of emotions that can stop us in our tracks, as if we were confronted by a passing stranger or as if we suddenly fell in love with an old friend. There is the matter of beauty, for example, of how to reconcile the personal reaction to seeing an incredibly beautiful landscape, whether for the first time or twentieth time, and of how to accommodate an extreme feeling of desire that somehow we must become part of that place, either through remembrance (say, in a photograph) or through establishment of a residence. There is the matter of opportunity, that we might make a fresh start someplace other than where we now live, or that we might renew our sense of purpose by staying put for the benefit of our family or for the good of the community. There is the matter of responsibility, that, if we decide to pull up roots, we leave our home in better condition than when we found it. And there is the ultimate challenge that, when we move into a new place, we must learn from it and embrace it completely, work hard at the improvements in an environmentally sound way, and then look back with an unbiased eye at what we have done.

Eventually, someone will walk the fence line and admire or criticize our handiwork, or will enter our house and take note of its design and furnishings, or will sit down with us on the front porch to learn more about ourselves and our place, or will drive past our land at sixty miles an hour and assess it with an immediate judgment—"Nice place" or "God's own junkyard" or "Ready for historic preservation." These scenes are available to every American because every American sooner or later has dreams of moving on and contemplates life in new places.

Imagine what Paula Chamlee's grandparents and their young children did in 1911. They left the comfort and familiarity of their home place in Iowa, with its excellent soils, for the unknown of a new place—the Panhandle town of Adrian, Texas. They abandoned the security of one home for the risk of establishing another. Such a decision to move, to trust in one's abilities and to accept chance, requires courage. But Americans have been moving physically and emotionally ever since each of us first encountered this continent—whether it was 30,000 years ago when we crossed the landmass from Asia where the Bering Strait now exists, or 300 years ago when we arrived in bondage from the Caribbean and Africa, or 150 years ago when we immigrated from Europe with hope for a better life, or 60 years ago when we escaped the inhumanity of Nazi Germany, or three nights ago when we left home in Ciudad Juarez in Mexico. Movement and the desire to be free are driving forces of our civilization, and they lurk in every nook and cranny of the American experience.

It is a huge artistic risk for a photographer to return home to a place she loved but knew she had to escape in order to discover her calling. But, in the tradition of the very best photographers who have concentrated on the interpretation of place and landscape, Paula Chamlee has found the means to channel her intimacy with and affections for a home place into an emotionally charged and deeply affecting view of life on the High Plains. Even as her camera accepts the limited spaces provided by her family farm, she expands our vision of what life and land mean.

Paula Chamlee's genius may reside in her restrained compassion and her absolute trust in her subject. In her first book, she looked to reveal the natural connections between people and places, to embrace the long-held idea that untrammeled beauty is worthy of our greatest respect. In this book she explores the multiple connections to the built environment that underlie human life and ingenuity; in this case, her home place in Texas. Her repertory now includes not only the expanse of Blue Mesa in Arizona, but also the confined and artful beauty of her dad's plowed fields and farm machinery; not only the Goosenecks of the San Juan River in Utah, but also the enduring image of cattle and a watering tank; not only the sounds of ocean waves breaking on rocks at Point Lobos in California, but also her brother's simple drawing in wet cement; not only the hot sulfur pools at Yellowstone National Park in Wyoming, but also the immaculate assembly of her mother's sewing station and the view of her kitchen.

Paula Chamlee directs her eye, heart, and soul toward her home place, and that love of place shines through with each photograph's beauty, grace, and composition. These are classical images of the commonplace. But Paula Chamlee's vision extends far beyond the High Plains life of a small farm in Texas; there is an implied appreciation for the landscapes of rural America and the ideals they represent.

The photographs in this remarkable book are full of information about who we are as a people and who we are as a nation. They remind us that, although the population of the United States has more than doubled since the year in which Paula Chamlee's paternal grandparents left Iowa for Texas, and although the United States has become decidedly urban and suburban in its economy and cultural sensibilities, and although television has replaced conversation and outdoor recreation for many Americans, the soil and the rural life that depends on its care still make this nation possible.

In the end, we are able to trust Paula Chamlee's photographs because she trusts us. She has invited us to visit her home place, to know what it was like to have been raised there, and to know that we must respect the land even as we change it. With this book, Paula Chamlee has given us a great gift that can be shared with future generations. She conveys to us, through the magic and integrity of photography, that truth can be found in beauty, and that beauty and knowledge can be found in common places.

GEORGE F. THOMPSON
President
Center for American Places
Harrisonburg, Virginia

INTRODUCTION

There is always that same feeling when I make the long drive into Texas, across the Panhandle, and am heading toward the home place—an exhilaration, a heightened energy that fills me with expectation and excitement. I become aware that my being is permeated with the feel and force of the wind, the smell of the soil, the blue of the sky.

The High Plains of the Texas Panhandle have lured many, but only the hardy have stayed. The winds can be fierce and unrelenting, the winters bitter, the rainfall scant, and the neighbors are often few and far between. The region attracts those who have a craving for self-sufficiency, love a challenge, or are just plain stubborn.

The rich history of the Texas Panhandle includes periods of habitation by a prehistoric people whose existence, along with the mammoths and giant bison they hunted, has been established at between nine thousand to eleven thousand years ago. The Panhandle's history is filled with evidence of the famed Spanish explorers—Coronado crossed it in 1541 during his quest for the seven cities of Cibola, and Juan de Oñate explored it in 1601. And there are accounts of the Comancheros (Mexican traders), who traded with the Indians during the seventeenth century, and of the nomadic Plains Indians—the Apaches, Kiowas, and Comanches—who dominated the southern Plains until 1870. Josiah Gregg, a famed Santa Fé trader, blazed the Fort Smith-Santa Fé Trail through the Panhandle in 1840, establishing a much used route for government expeditions, speculators, and the multitudes of gold seekers headed for California. By 1875, when the last of the Plains Indians had been subdued by military force and were confined to reservations, the region was ripe for the overwhelming push of the most recent inhabitants, the enterprising Anglo-Americans.

The Republic of Texas came to an end with annexation to the United States in 1845, but it was not until the end of the Mexican War in 1848 that the final boundary lines of the Texas Panhandle were drawn. Established through heated political battles, the revised perimeters greatly reduced the size of Texas's territorial claims on the northern and western boundaries and defined the shape of the Panhandle as it is known today. For the new State of Texas, the periods of territorial conquest were over.

The Anglo-Americans enjoyed the use of the vast and rich grasslands in the State of Texas's public domain, lands that were leased or purchased for a pittance and that were ripe for profits to those willing to risk the capricious and

extreme weather conditions. In 1876, an experienced frontiersman and veteran cattleman, Charles Goodnight, brought herds down from Colorado onto the great open grasslands of the High Plains and established the first cattle ranch in the Panhandle. In 1877, Goodnight partnered with John Adair, an Irish banker and cattleman, and together the two men grazed many thousands of cattle on more than a million acres of land.

Arriving at the same time, Casimero Romero and other Spanish sheepmen came from New Mexico, bringing thousands of sheep into the Panhandle north and west of the Goodnight-Adair claim. With no local government and with only a handshake territorial treaty between cattlemen and sheepmen, it was still a rancher's dream—free water and free grass, no manmade restrictions, and almost limitless acres upon which to fatten cattle for the thriving market in Dodge City. On the other hand, there were no convenient supply routes, no railroads, and no recourse for the bad years brought by a climate that was under no man's control.

As the outsiders began to see that drought and bitter winters combined with absentee and inexperienced management could wreak havoc on profits, they turned their miscalculations into enterprising ventures by publicizing this "land of opportunity" to another group of unwitting but hopeful pioneers. They aimed their extensive, albeit misleading, advertising toward the high-priced farming country of Ohio, Indiana, Illinois, and Iowa.

Thus, the first farmers traveled to the Texas Panhandle at the invitation of the railroads, foreign land syndicates, Eastern investors, and the ranchers who had failed to weather the bad years. A rush of new settlers began pouring into the region during the early 1900s, generating one of the largest land booms in the country's history up to that time. And they were coming at the behest of—yet to the dismay of—the ranchers. Despite disagreements, these early ranchers and farmers quieted their differences and together began to tame and shape the region into a civilized, livable, and prosperous territory, one that the explorer, Captain Randolph B. Marcy, on an expedition for the U.S. Army in 1849, had declared to be "… a region almost as vast and tractless as the ocean—a land where no man, either savage or civilized, permanently abides; it spreads forth into a treeless desolate waste of uninhabited solitude, which always has been and must continue uninhabited forever." When Captain Marcy made those notes, he was camped only eight miles west of present-day Adrian in Oldham County—about twelve miles from where my parents' farm is located.

Henry and Lillie Creitz, my paternal grandparents, came to the Texas Panhandle in January of 1911, following the inducements of the American-Canadian Land and Townsite Company, whose promotions promised cheap land, plenty of rainfall, rich soils, balmy winters, and a host of other too-good-to-be-true attractions. They came from Iowa, where the price of good farm acreage was higher than it is even today in much of the Panhandle.

They were carried by the Rock Island Railroad to the end of the line and a new town called Adrian, one of the towns built by the railroads along the westward route. My grandmother and their two children rode in a passenger car, and my grandfather rode in a freight car with his horses and cattle so that he could tend to them. My father was two

years old when the family made their long journey on the emigrant train to their new land.

They had come to claim their first quarter section, 160 acres of tillable soil—twice as much land as they had previously farmed. They paid less than eighteen dollars per acre, one twentieth the value of Iowa acreage. One hundred and sixty acres must have seemed enormous, but my grandparents quickly learned that the harsh and semi-arid High Plains require significant acreage to produce a sufficient living, so they soon added another quarter section to their farm.

From the train depot in Adrian, the Creitz family made a temporary home at Adrian's only accommodation, the Giles Hotel. But they soon struck out across the short-grass prairie to the new homestead, four miles east of town as the crow flies. And "as the crow flies" was the way wagon trails were wont to go over this great and uninterrupted flatness— the open grassland that was yet to be broken by the plow. The beaten trail across this expanse had to suffice as graded dirt roads did not come until more than a decade later. When the family arrived, there were barns and a house to build, crops to plant, and fences to put up.

My father, Lorin Rhine Creitz, bought his own first quarter section of land in the mid-thirties at fifteen dollars per acre in partnership with his younger brother. This farmland adjoined that of their parents, and my father lived and worked at home until 1940, when he borrowed the money for his first full section of land—640 acres—one square mile of his own, a few miles west of his parents' farm. He married my mother the following year.

My mother, Armenia Elliott Creitz, descended from pre-Civil War native Texans, had grown up on a farm in Grayson County in East Texas. After graduating from North Texas State Teacher's College in Denton, she was offered an assignment at the school in Adrian, an outpost she was sure was at the ends of the earth. Good jobs in the late thirties were scarce, and she feared that if she missed this chance, she'd be hard at work on the family farm again. The assignment in the hinterland held unexpected promise—she was surprised to discover there were many eligible bachelors in Adrian—and she soon picked out the one she wanted.

Lorin and Armenia began their life together building a family and a homestead on the western side of the Panhandle on the Llano Estacado in Oldham County, a few miles south of Adrian. The little town lies on old Route 66, forty-eight miles due west of Amarillo, and twenty-three miles due east of Glen Rio on the New Mexico border. Amarillo has a population of about 157,000, Adrian has a population of about 220, and Glen Rio has a population of 2. My brother, sister, and I were all born in a hospital in Amarillo, and to this day the nearest doctor is still fifty miles away.

Cattle and hard grain winter wheat are the primary commodities of this northwestern region of the Panhandle. The more lucrative oil and gas fields begin to the north and east of Oldham County. My parents' farm lies on a narrow band of land along the Ogalalla aquifer, where the water table is too low in order to irrigate economically. Since the area depends on the fall rains and winter snows for the establishment and nourishment of the young wheat and natural grasses, dry land farming is the only viable method, yet one that is at best a fearful risk. Being always at the mercy of the weather, my father had many years in which he made virtually nothing, when drought, hail, fierce winds, or

blight stunted the income along with the flowering heads of wheat.

The unpredictable and extreme weather, combined with the Great Depression, the Dust Bowl years, and the Second World War, taught the Plains farmers of my parents' generation to save everything and to live conservatively for the all-too-likely lean years ahead. Even though there have been fairly prosperous times on and off through the years, life has been more about survival than about pleasure, and the credo has always been: "Use it up, wear it out, make it do, or do without."

Over the years, my parents added additional acres to their farm, and along with the wheat and feed crops, they raised chickens, hogs, and cattle. When they were in their seventies, they allowed themselves a level of retirement by phasing out the livestock and the feed crops. Now they lease their pastureland to a local cattleman and assist with the care and supervision of his herds. Today, in their mid and late eighties, my parents continue to raise a wheat crop and to farm their 1,100 acres all by themselves.

I left the farm to go to college less than a month after high school graduation—I couldn't wait to get out. Hungry for adventure and independence, I wanted to see the world and experience a broader life.

I lived outside of Texas in many different regions and worked in many different fields. With no exposure to the visual arts at home, in school, or in the local community, I found my way into the field where I belonged—first as a painter, then as a photographer—only after many years had passed.

Although there have been yearly visits back to the farm over the thirty-three years since I moved away, only in recent years have I felt compelled to return there to photograph in depth. I've wanted to photograph the farm while my parents are still active—while the extraordinary energy and spirit of their presence fills this home place.

PAULA CHAMLEE
Ottsville, Pennsylvania
August, 1996

THE PHOTOGRAPHS

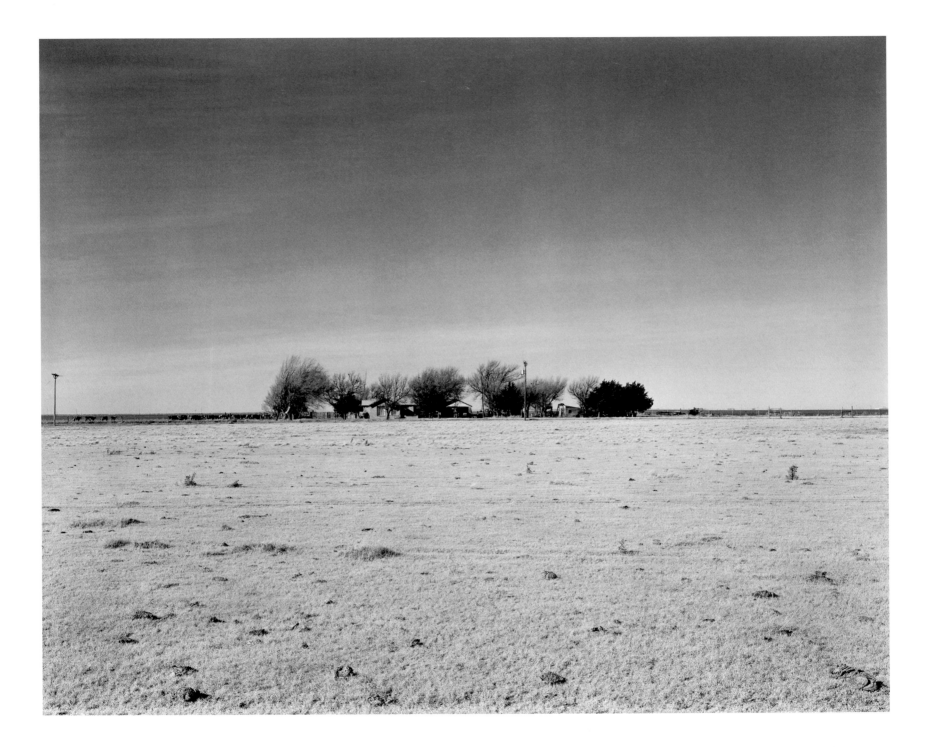

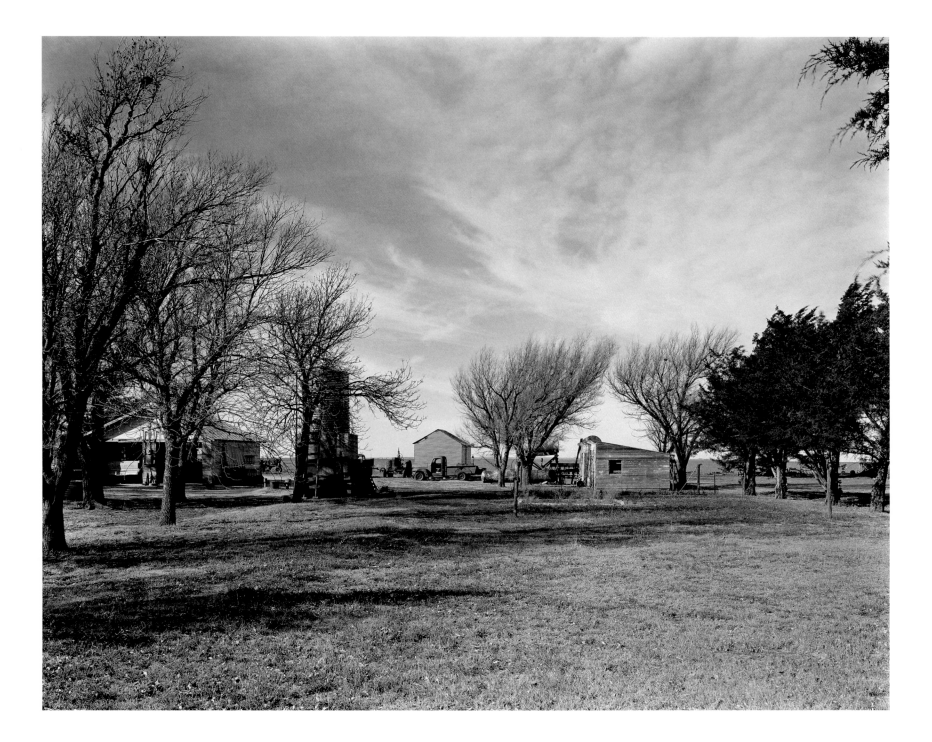

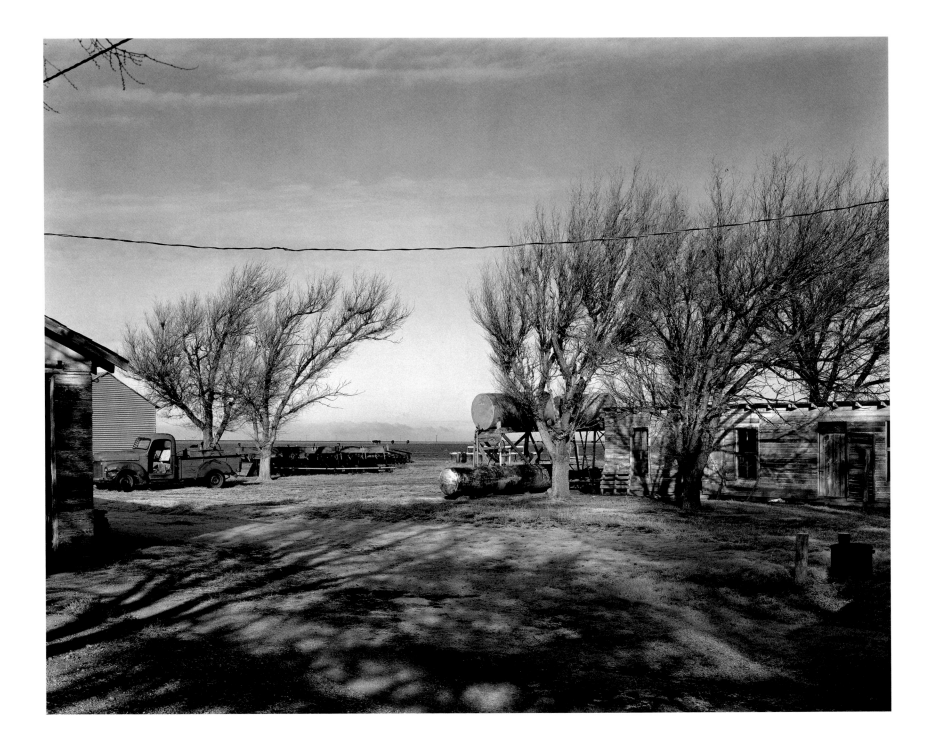

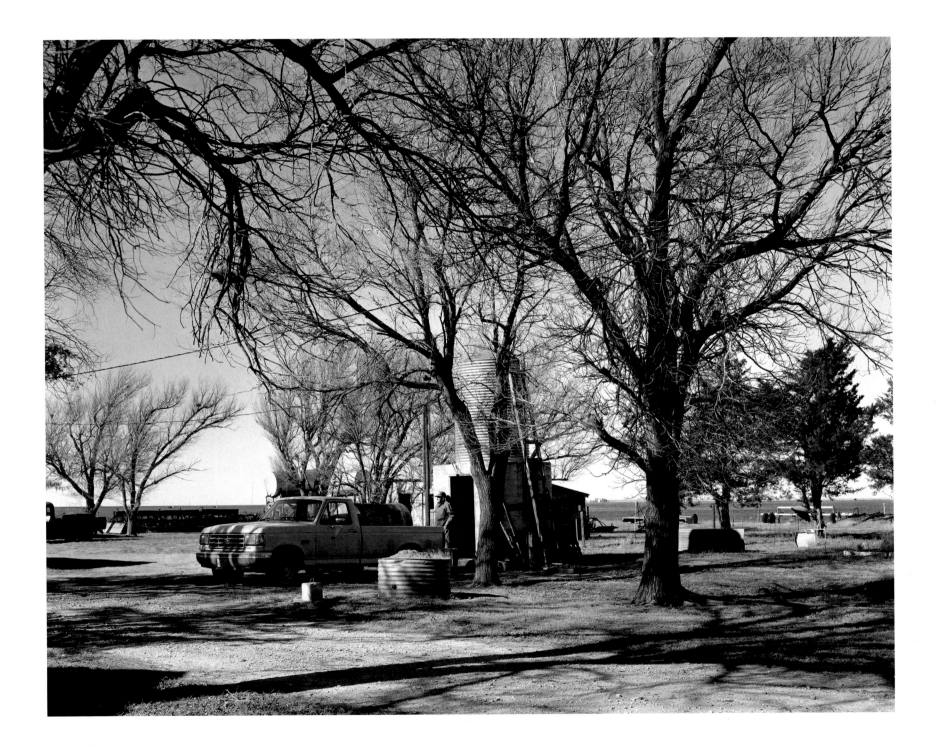

No trees grow naturally on the High Plains where my parents' farm is located. Mom and Dad brought every tree from other areas and planted them themselves.

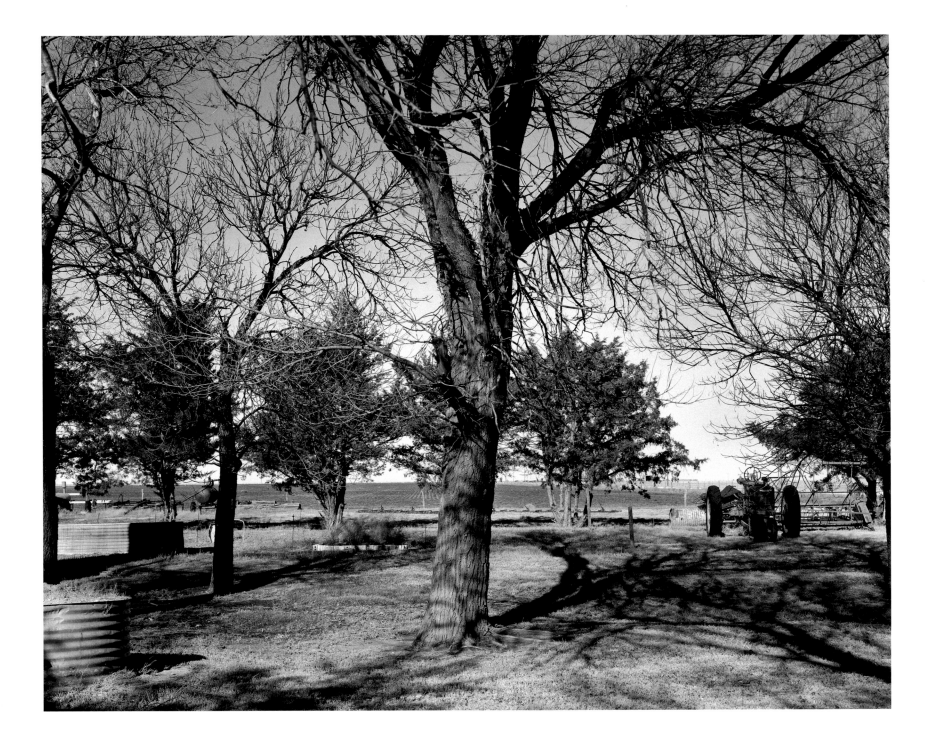

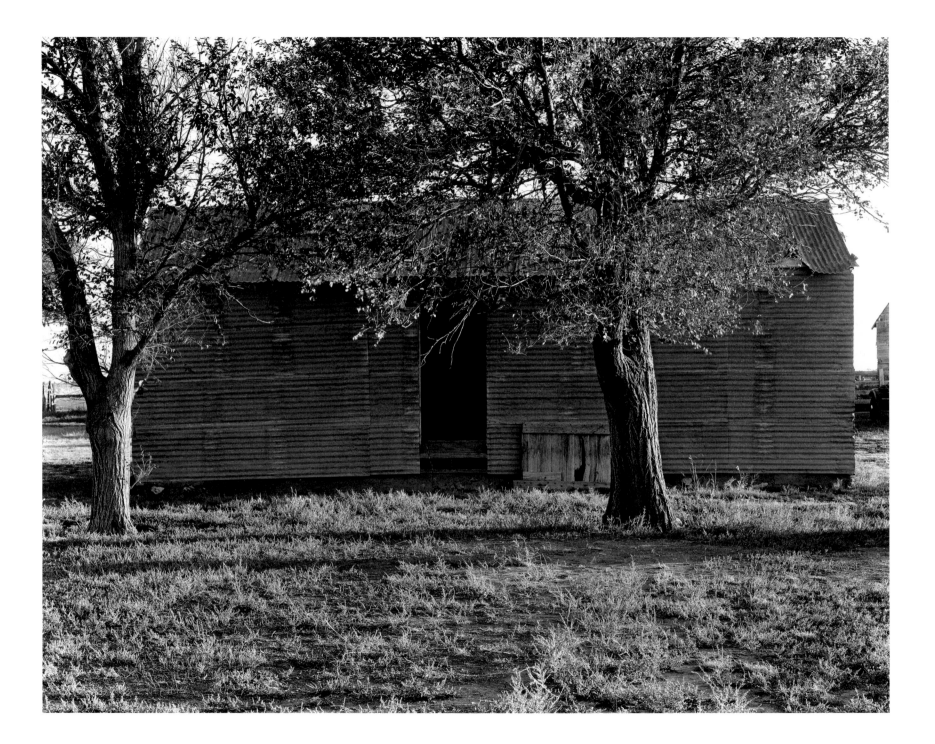

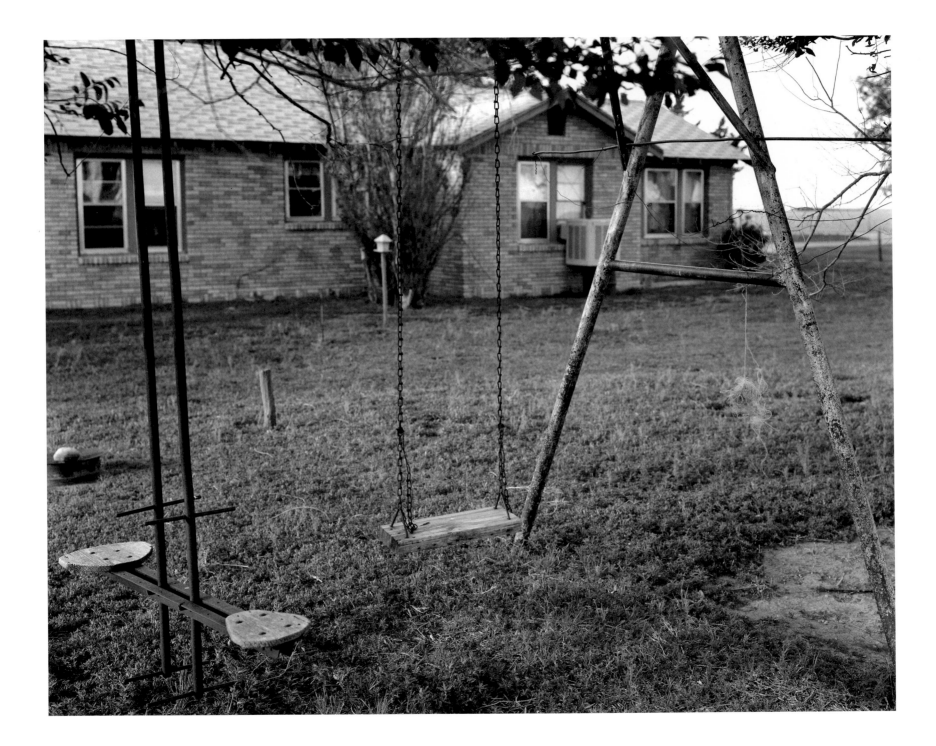

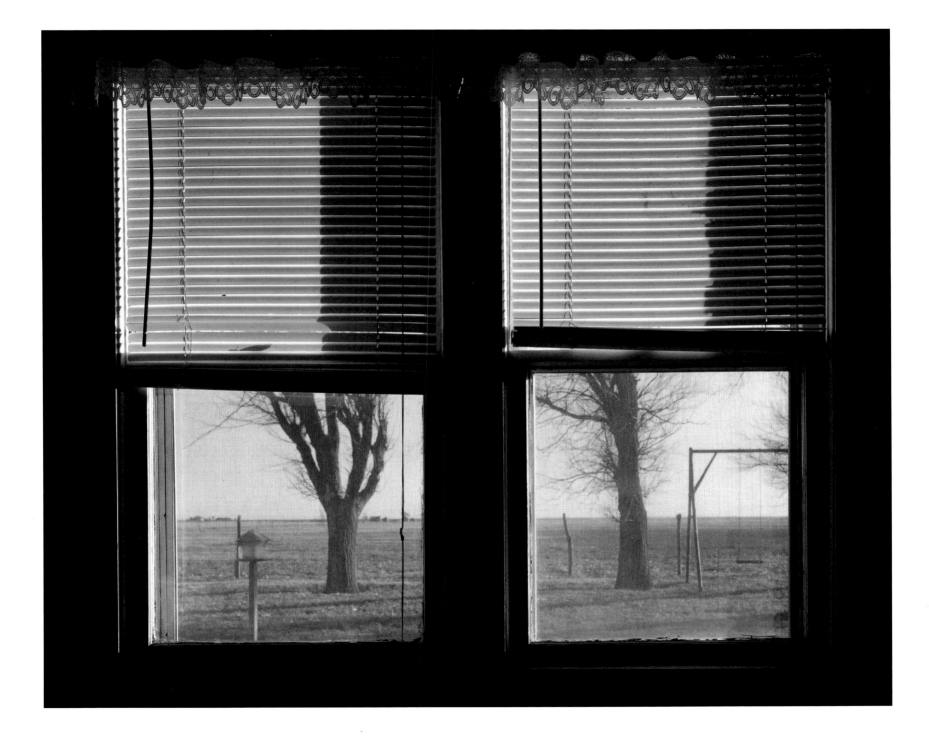

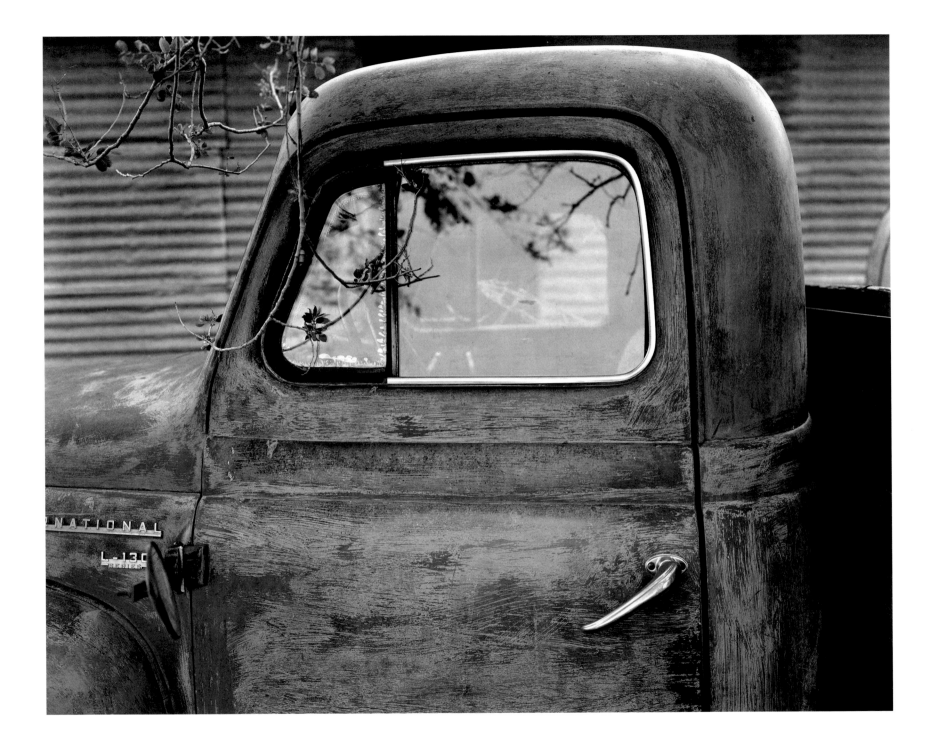

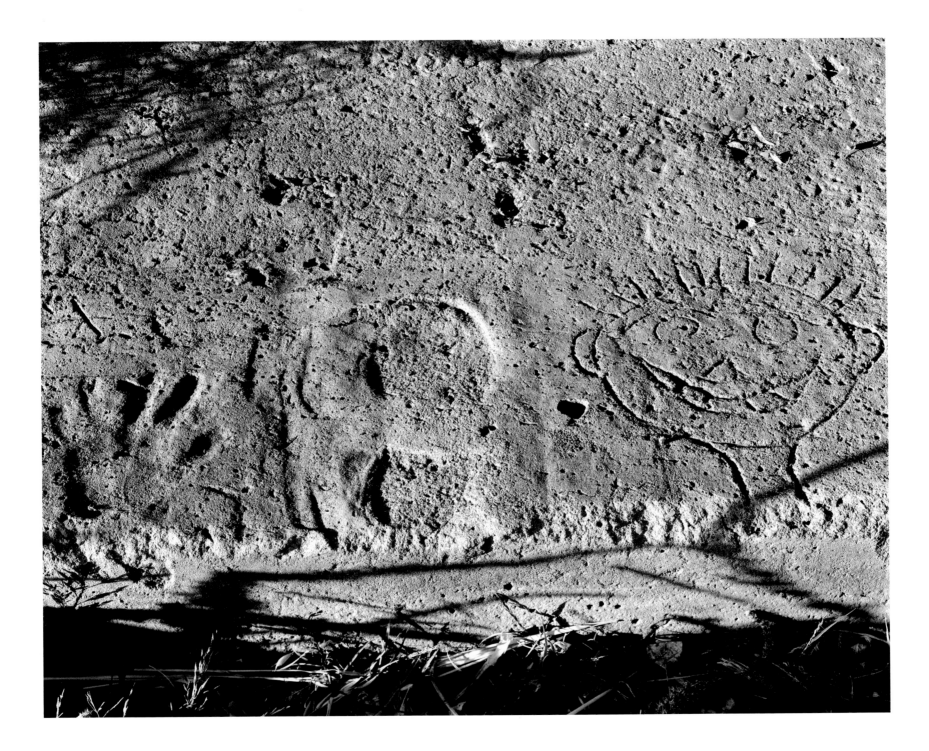

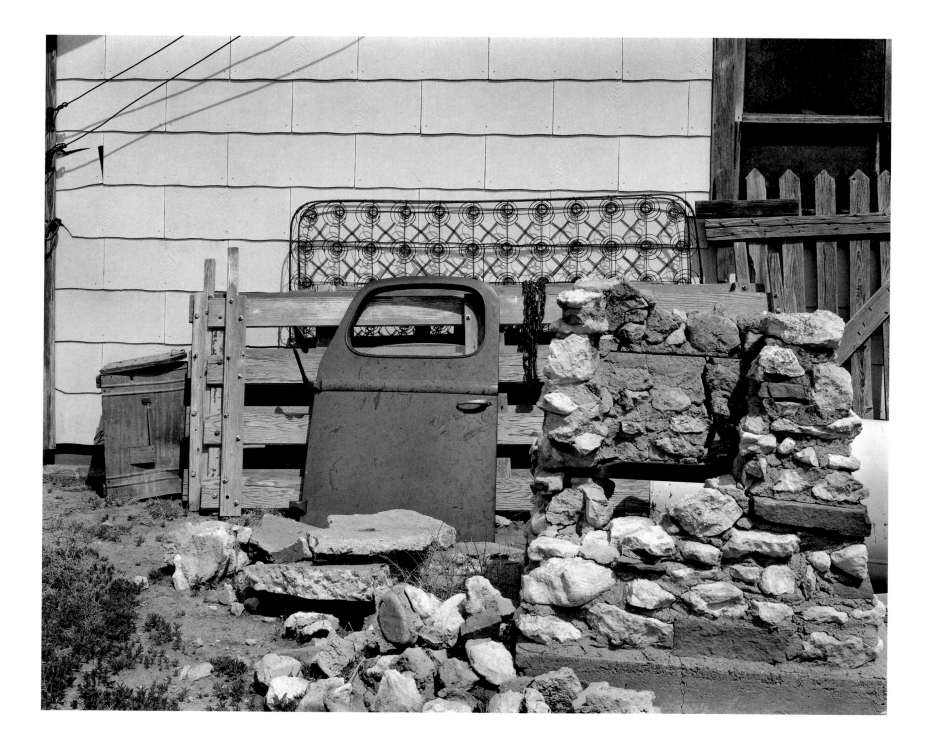

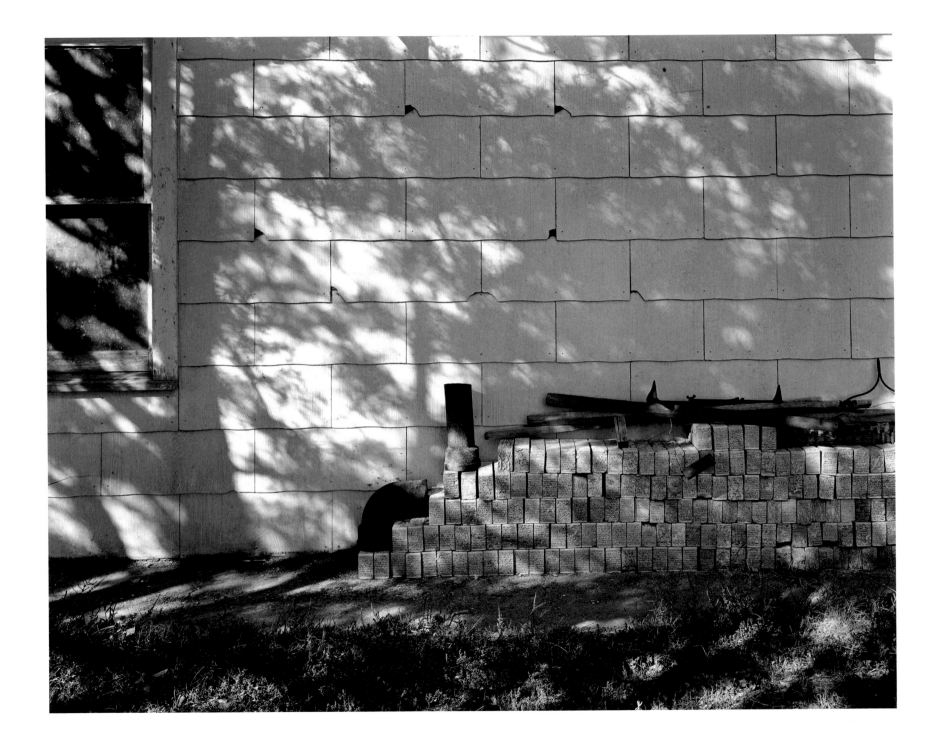

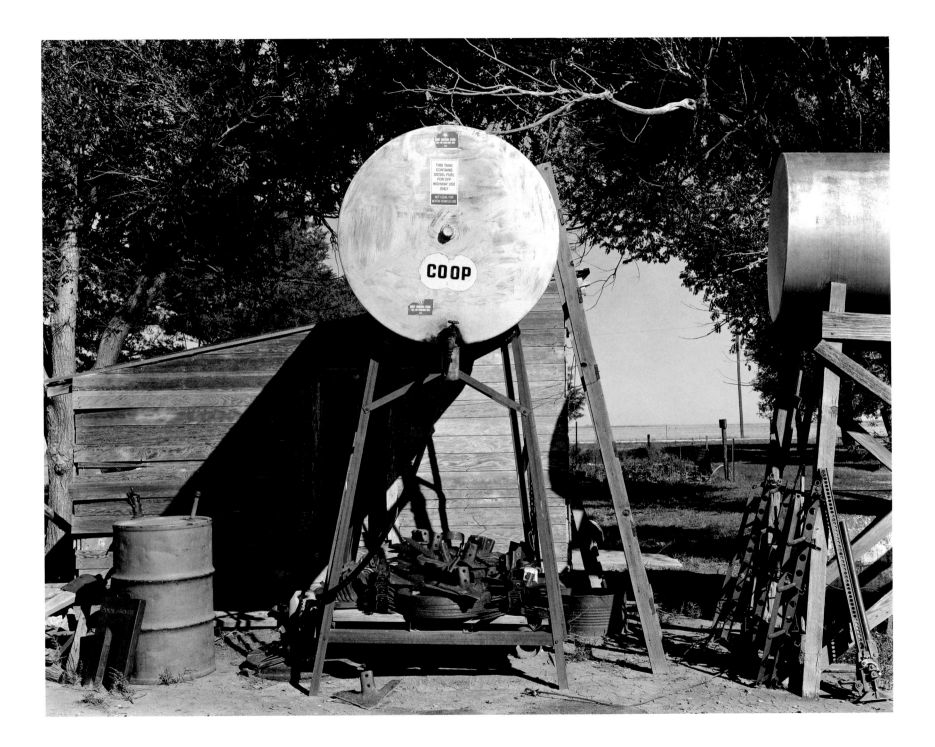

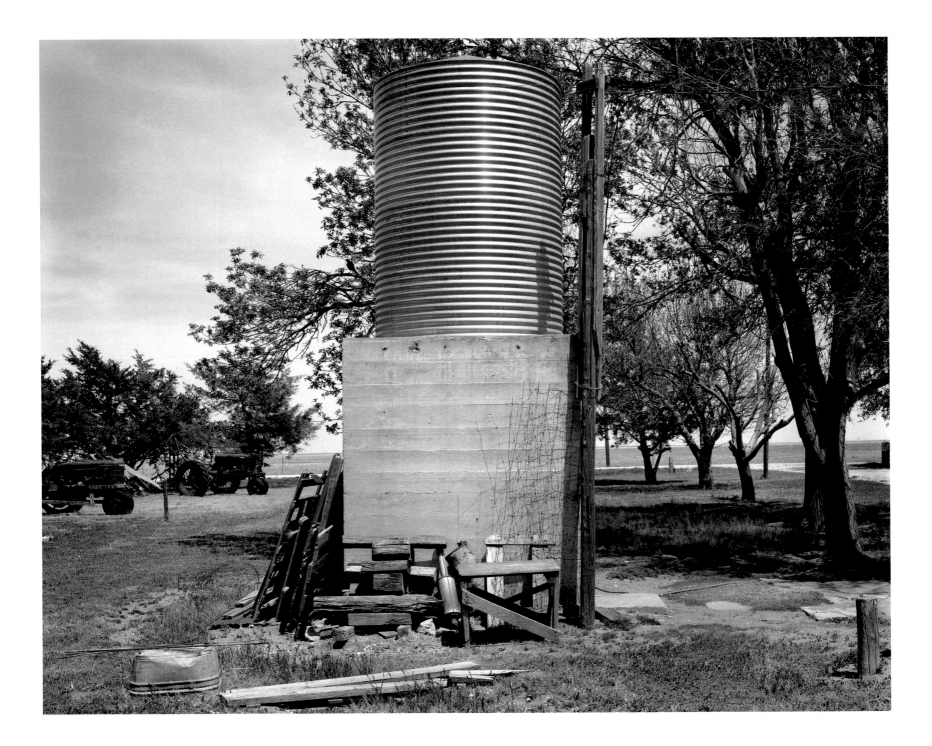

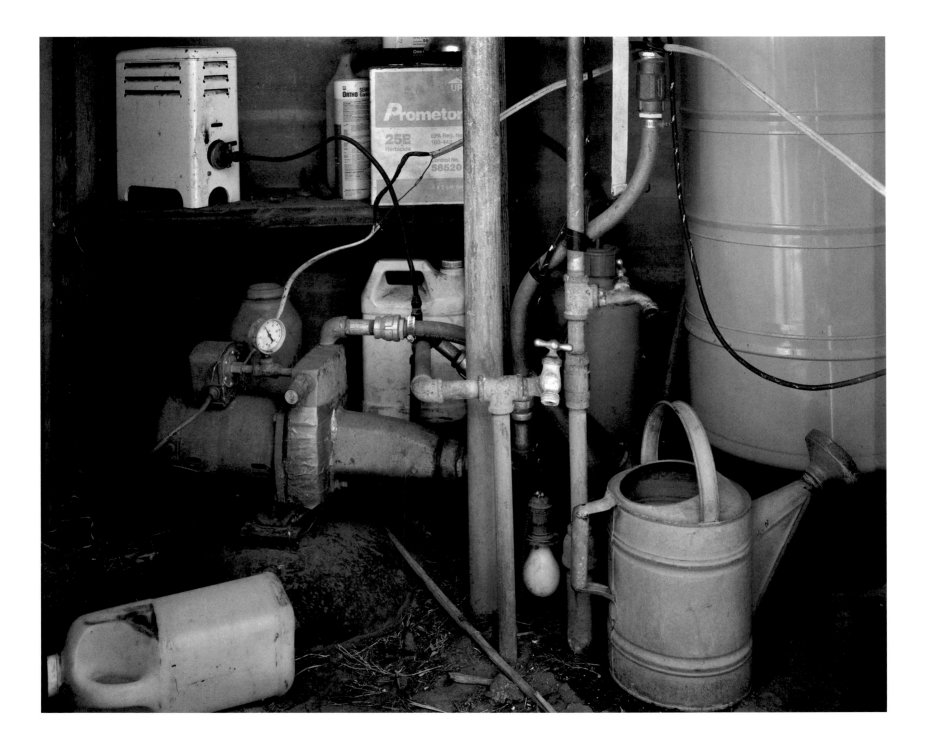

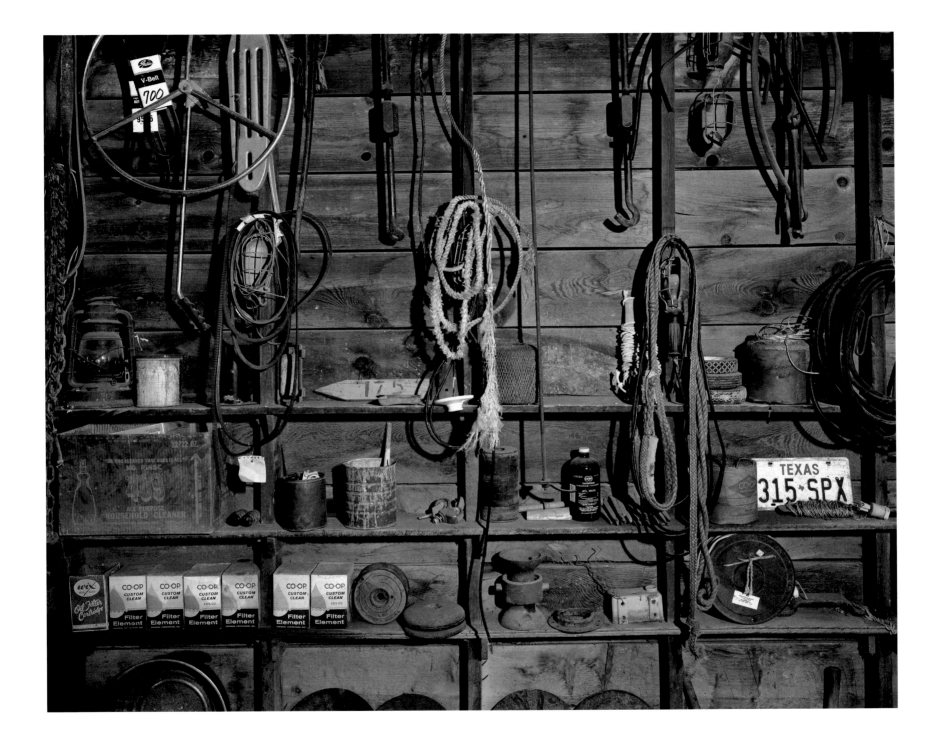

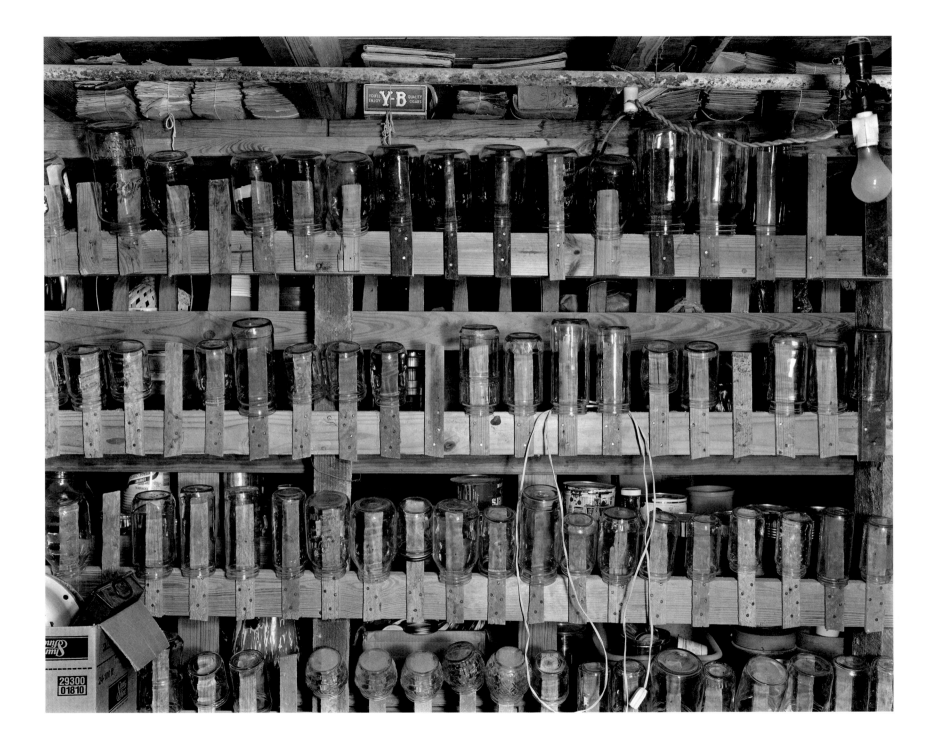

As I enter the house, I am flooded with memories, for the house smells exactly the same—somehow a comforting reassurance—filled with those unique odors that describe a place beyond vision, describe and recall the days of past years, powerful olfactory sensations flooding the mind.

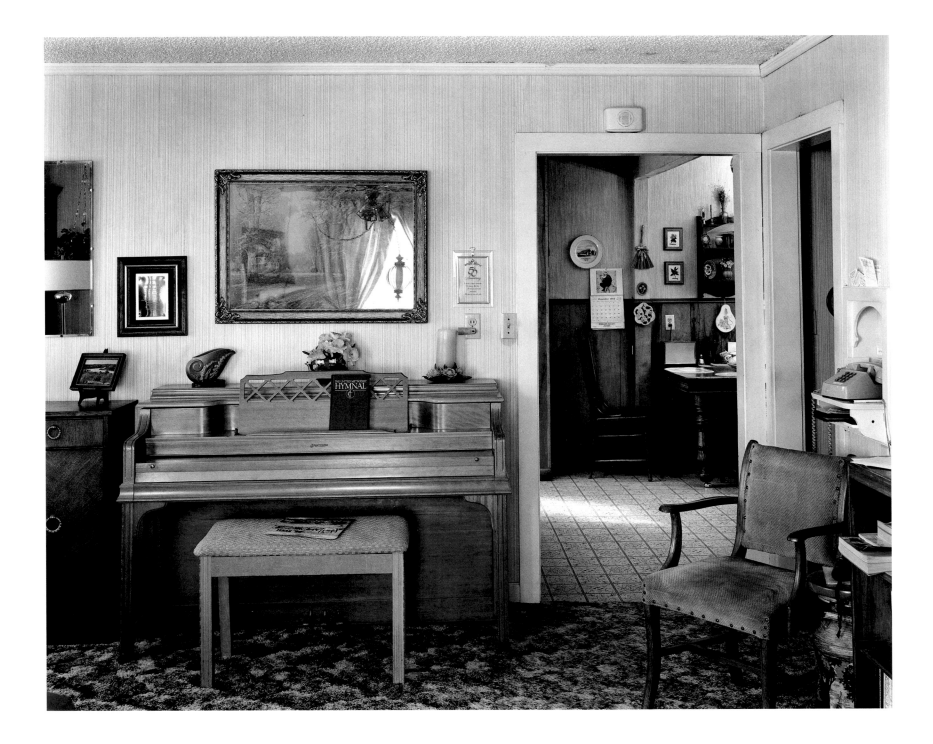

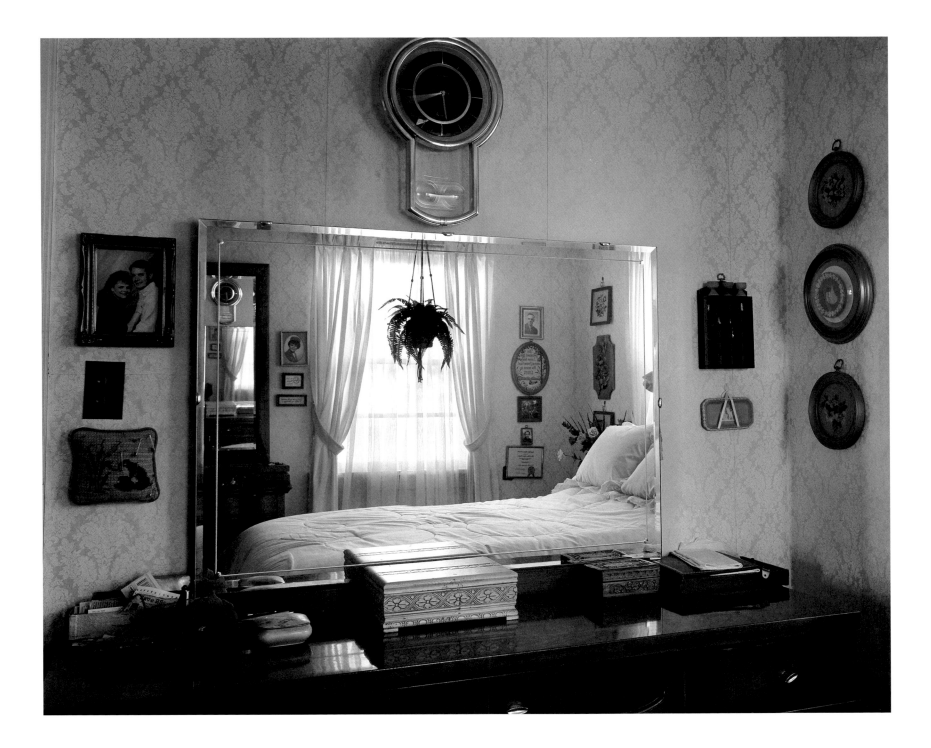

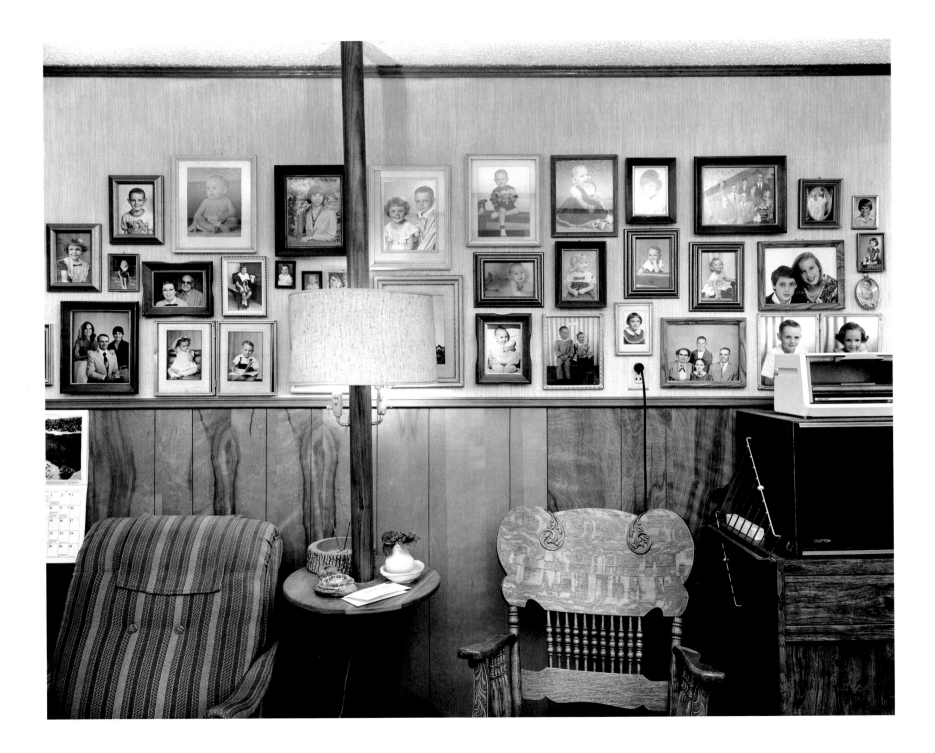

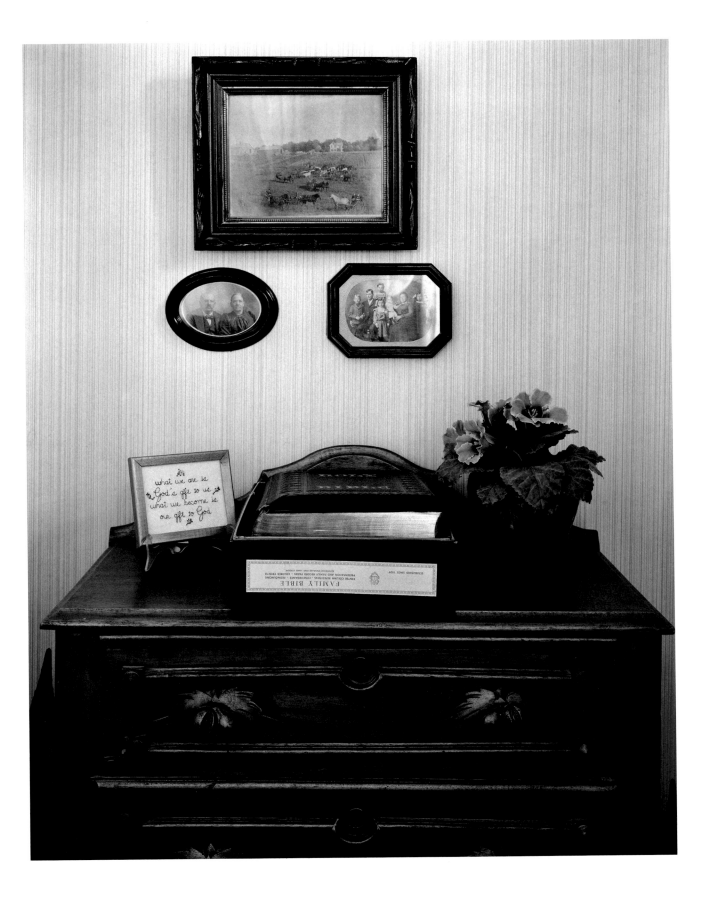

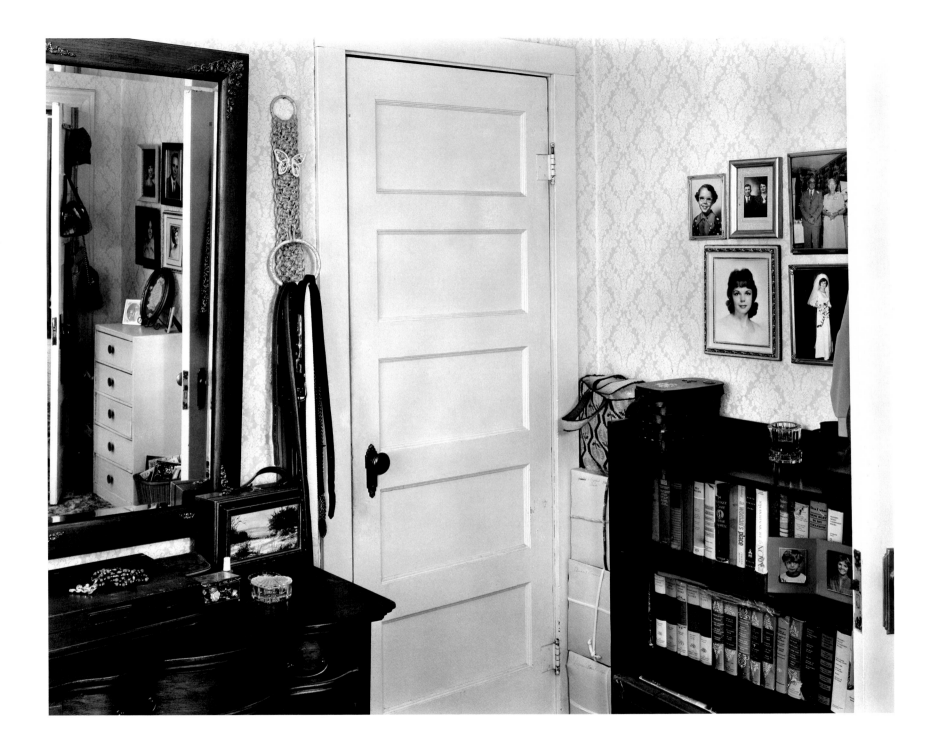

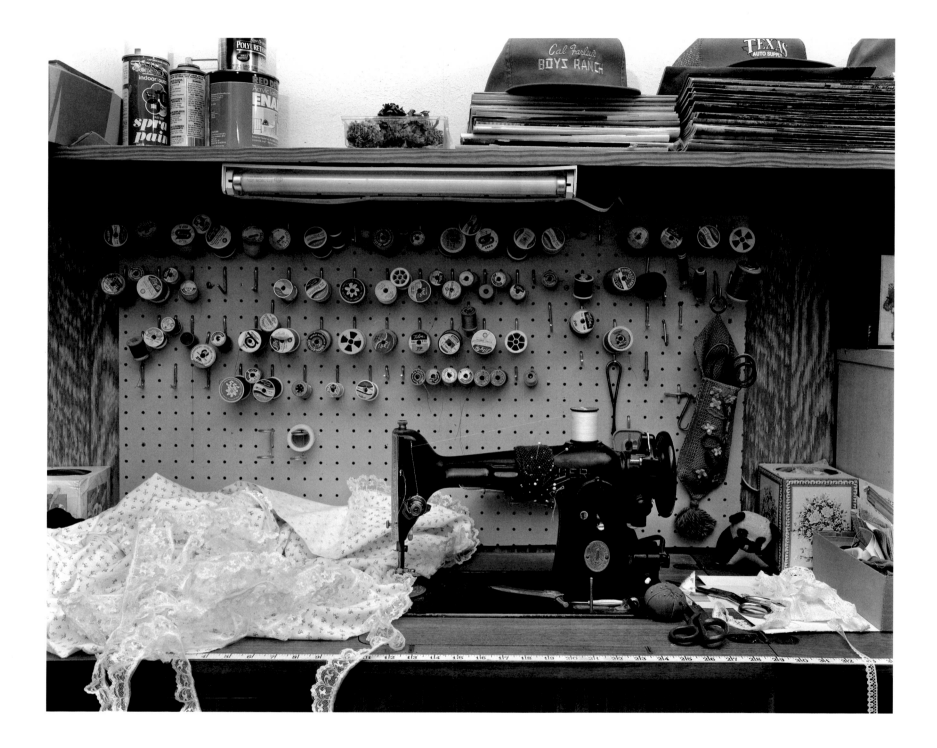

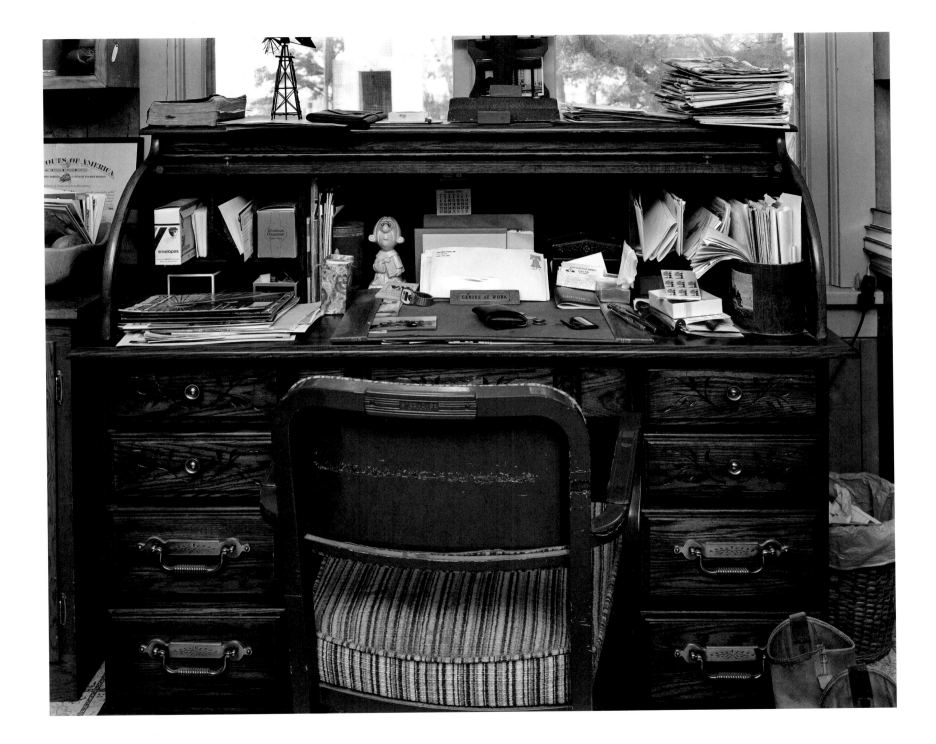

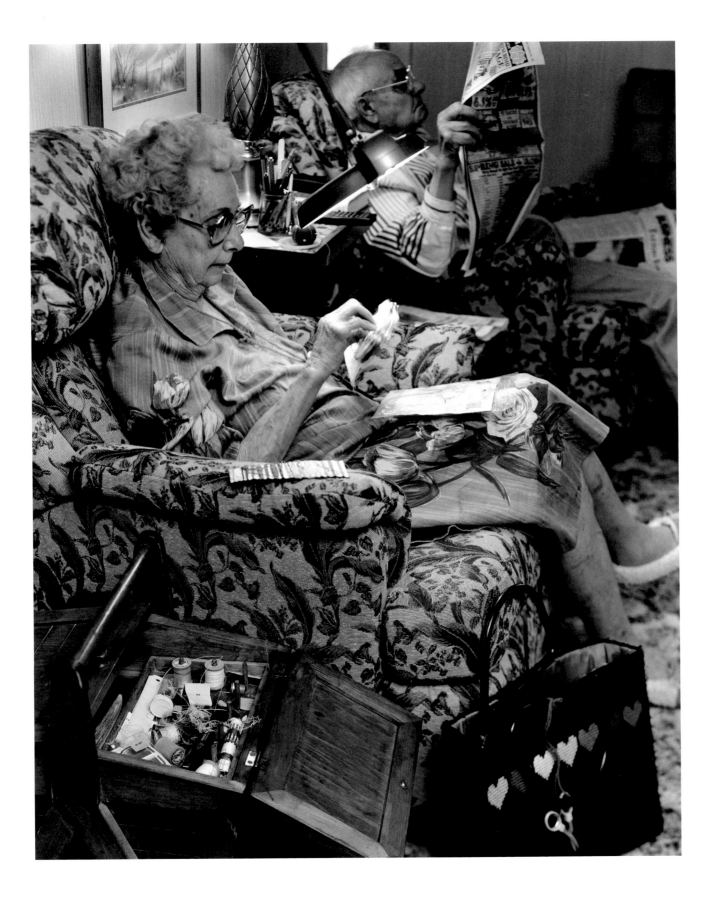

Our house never had a functioning lock on any of its doors. I remember once, as we were about to leave for several days on a trip, asking my parents if we were going to lock up the house. "Of course not," was the answer. "What if the neighbors need to get in to borrow something or check on things?"

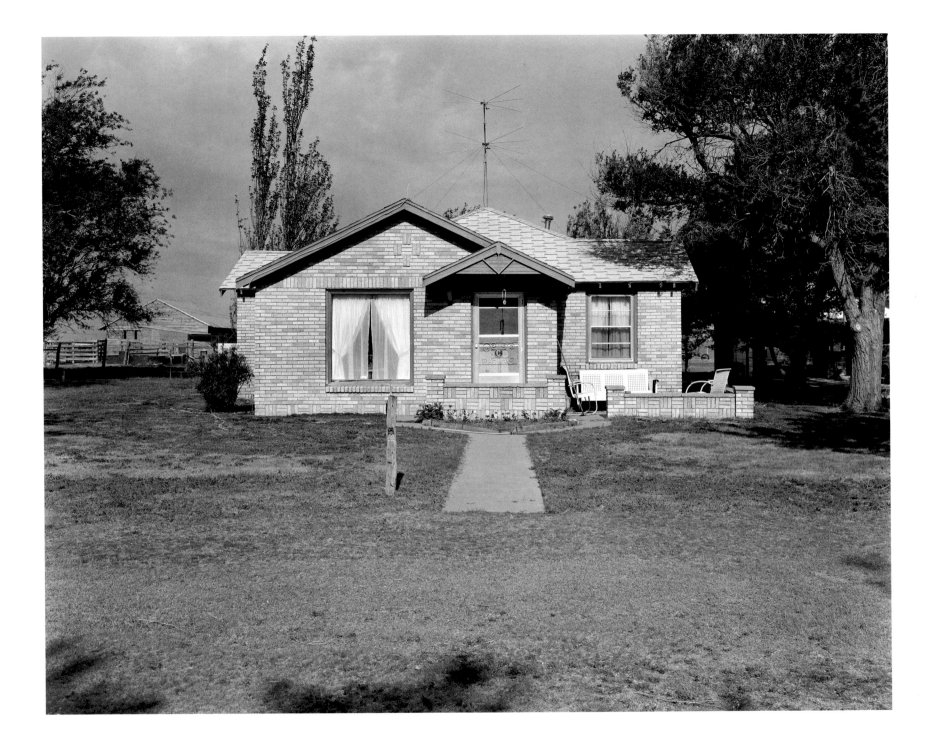

My dad built all of the barns, outbuildings, corrals, and fences.

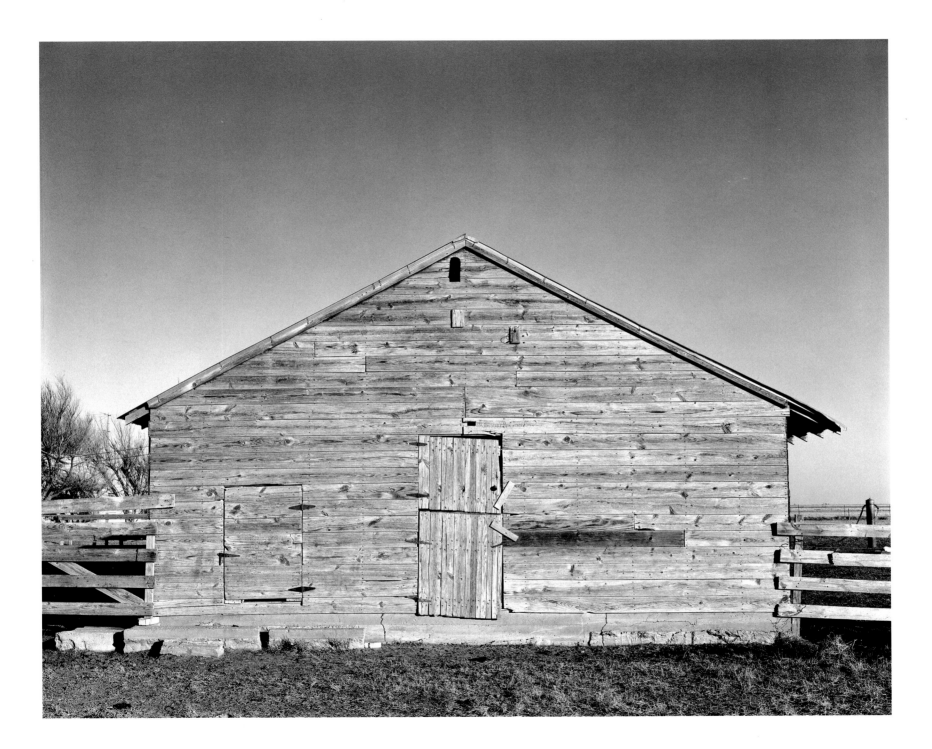

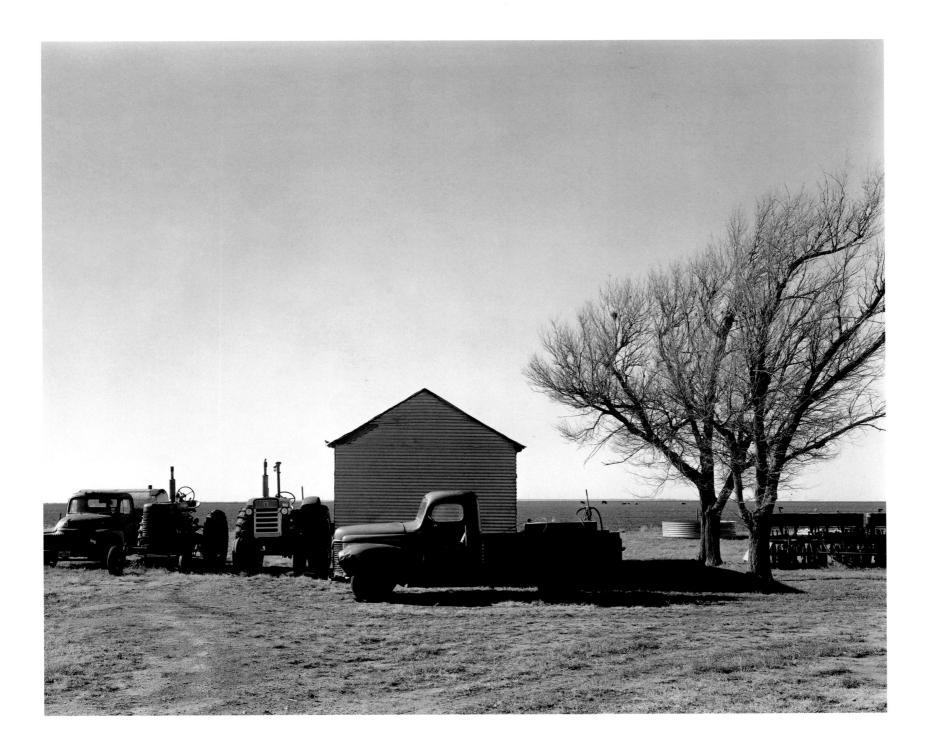

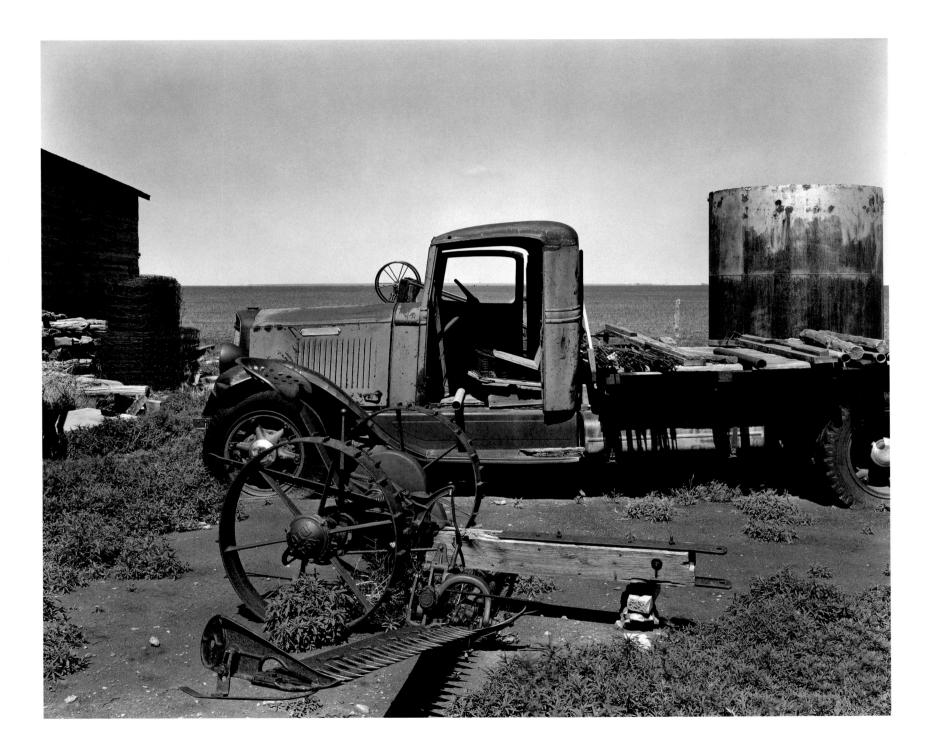

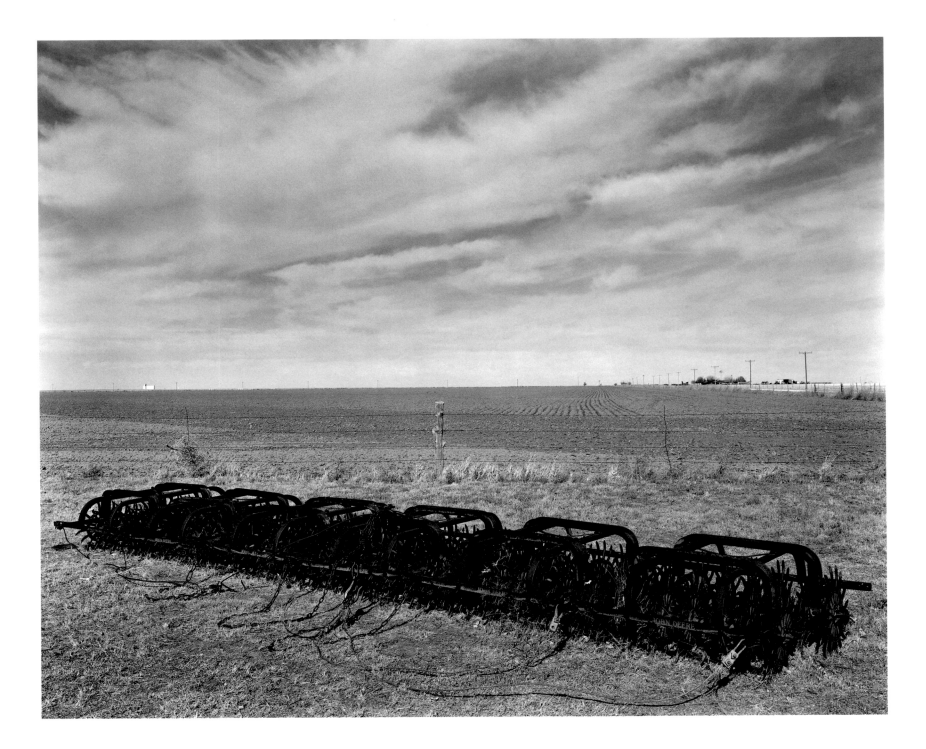

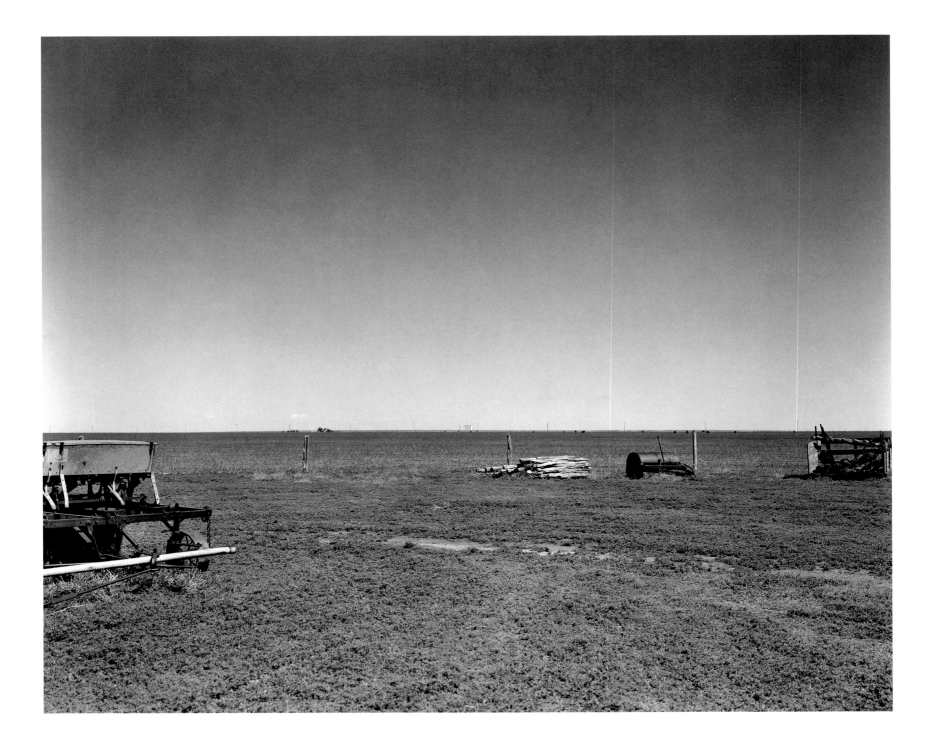

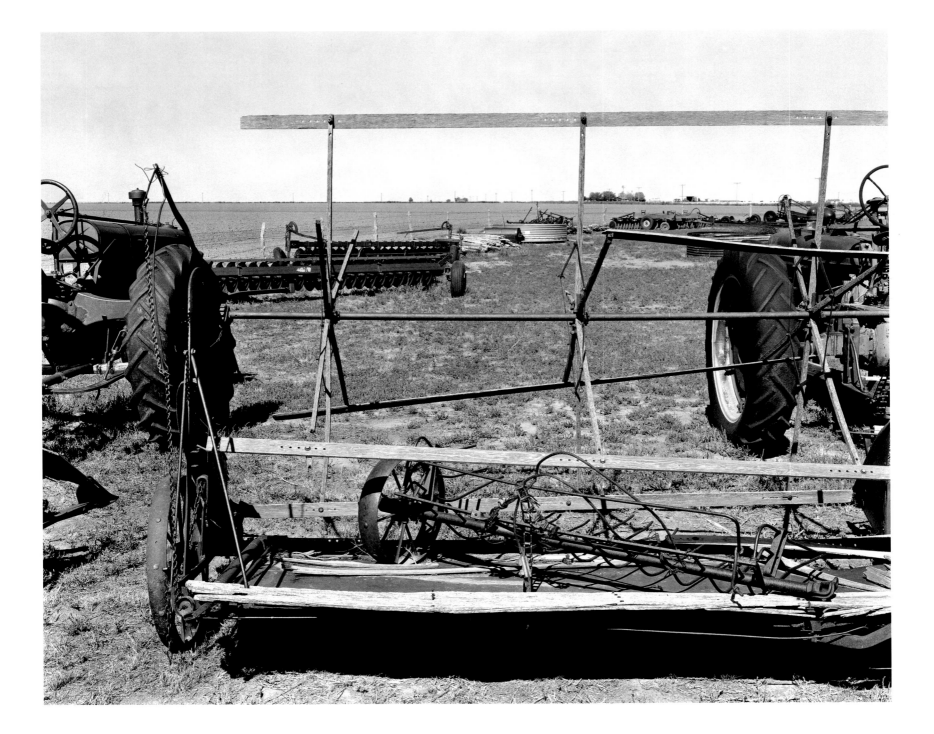

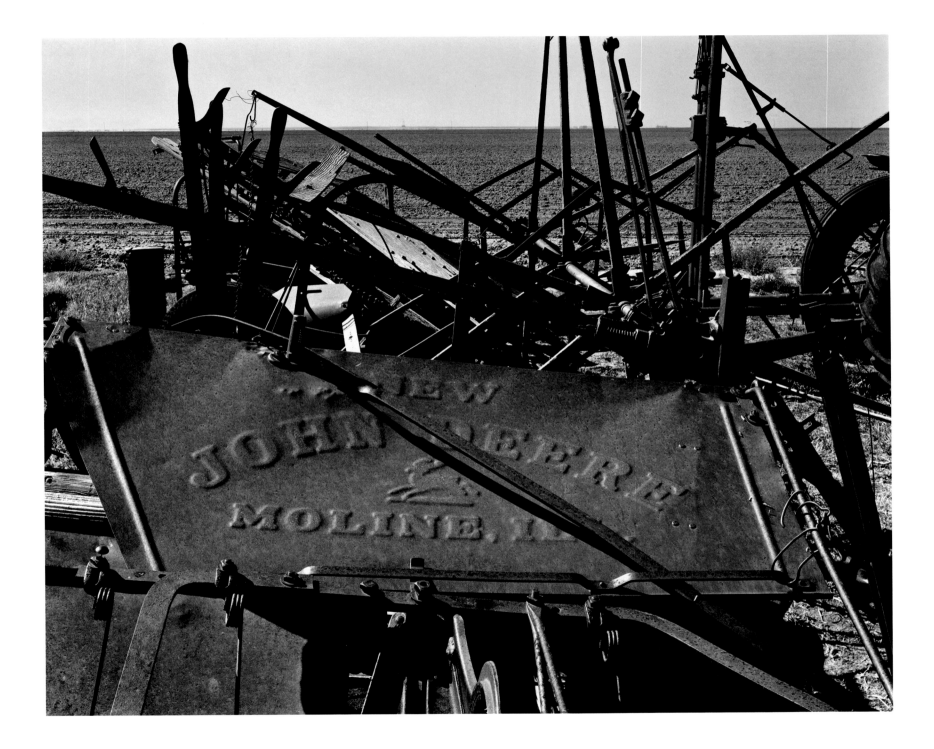

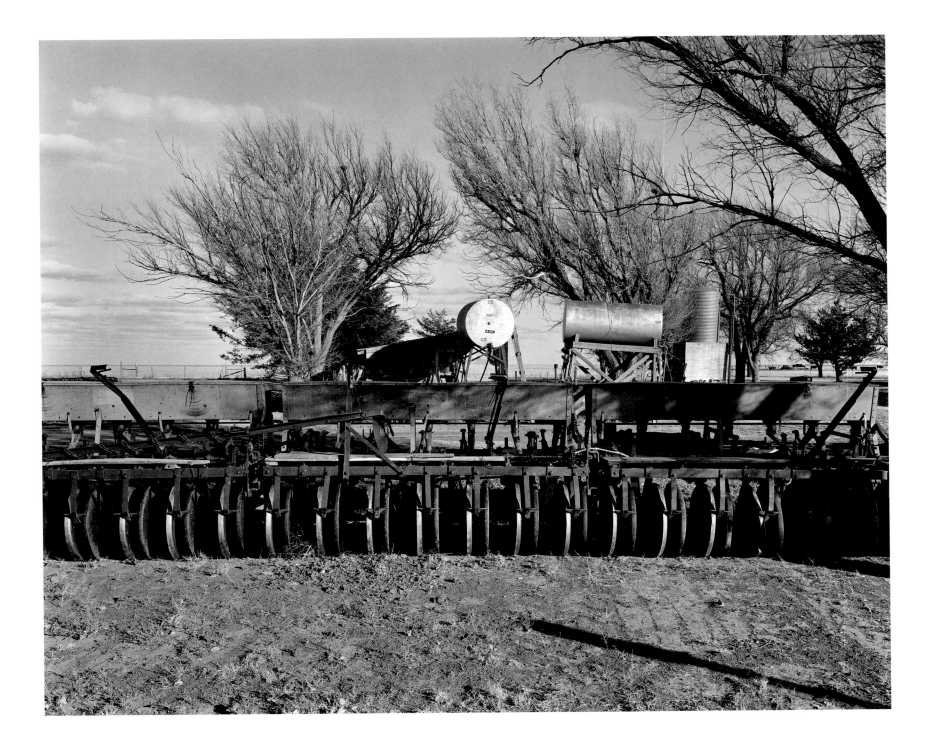

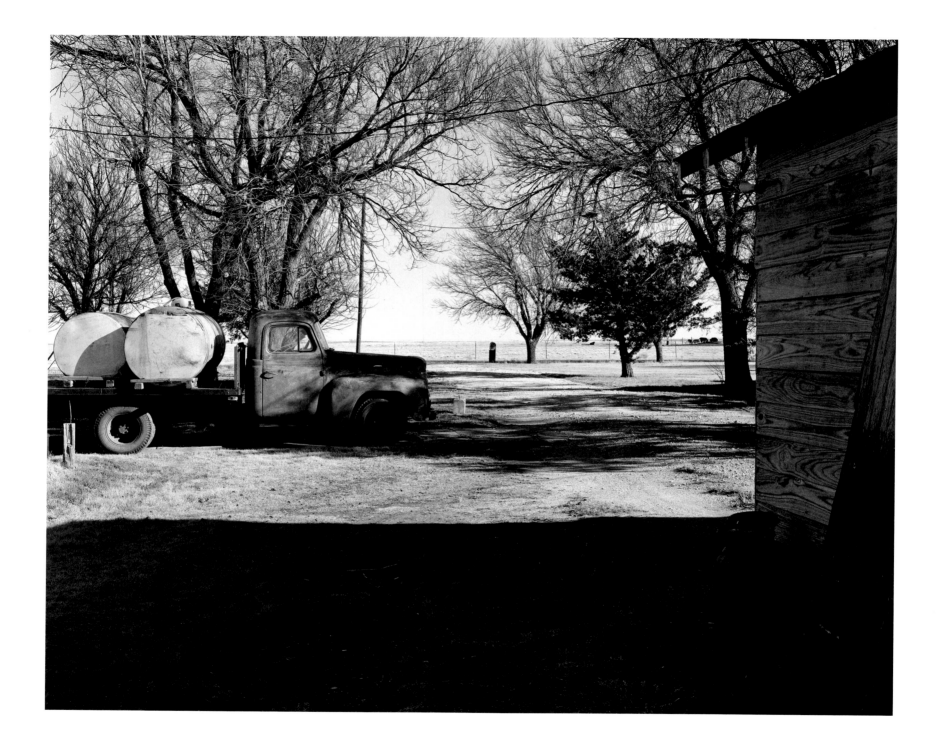

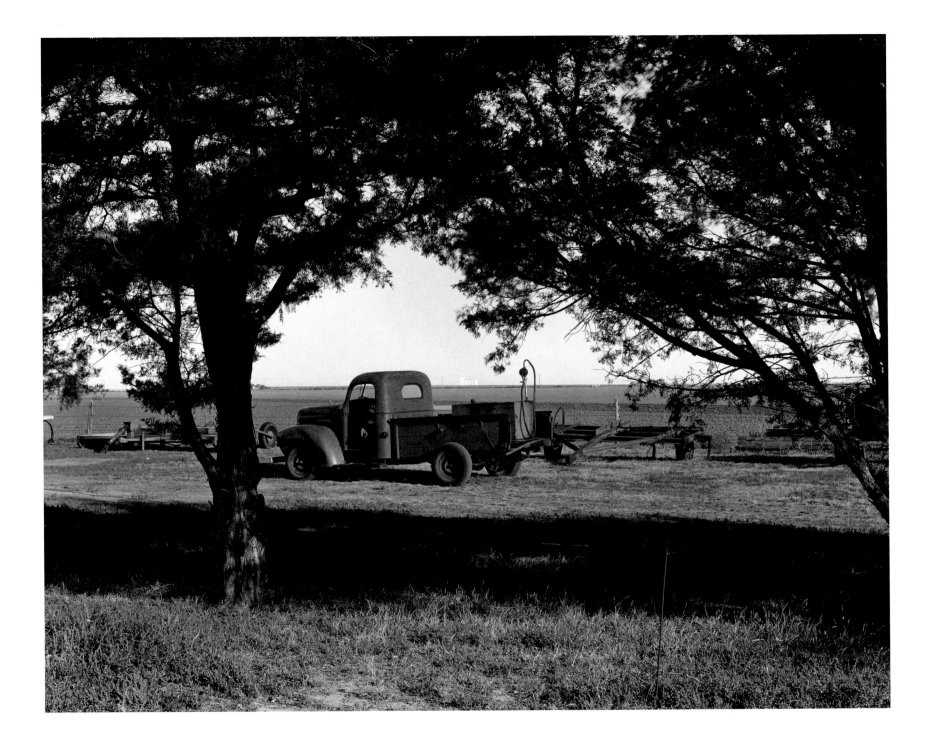

Vehicles from seven different decades—the 1920s through the 1980s—are still in use on the farm.

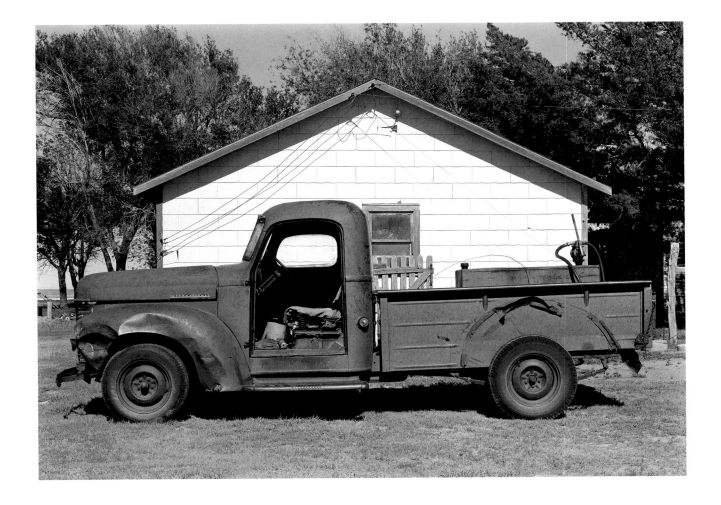

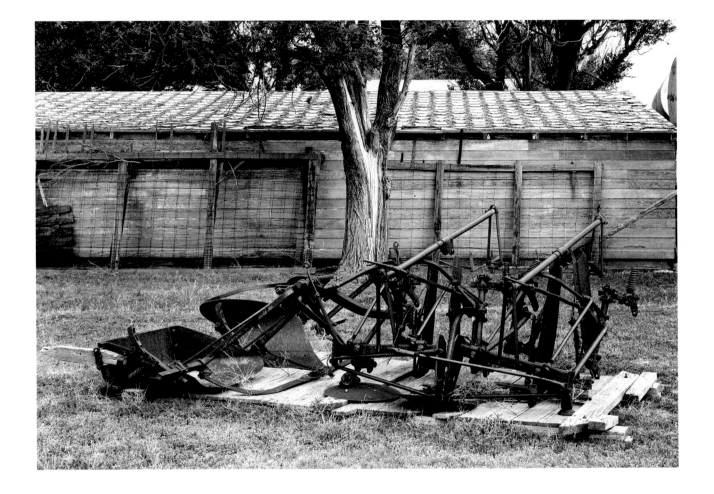

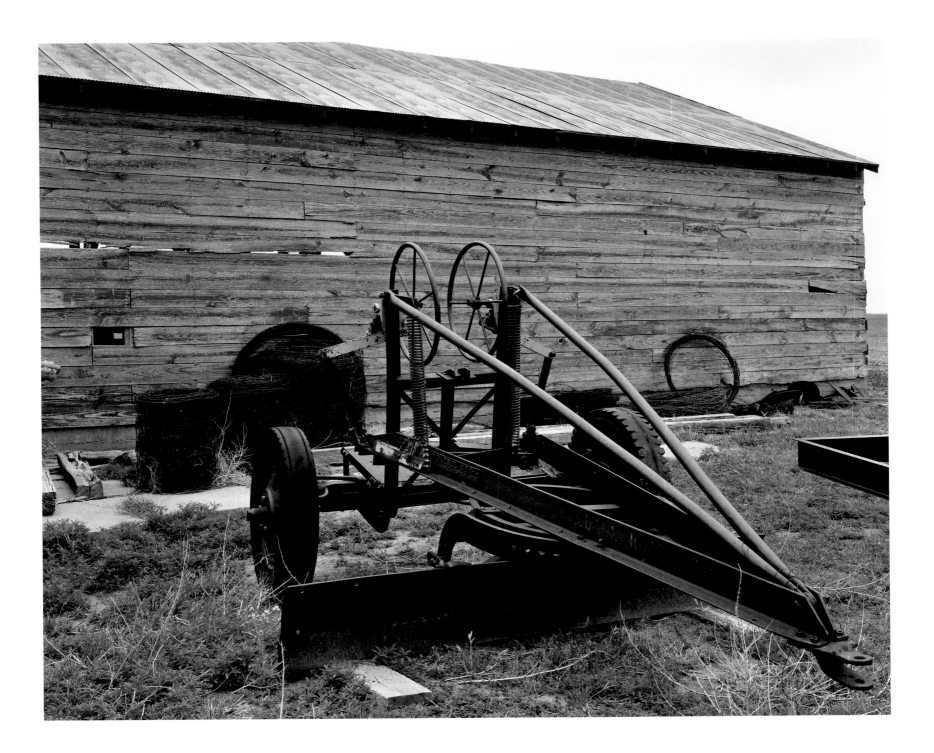

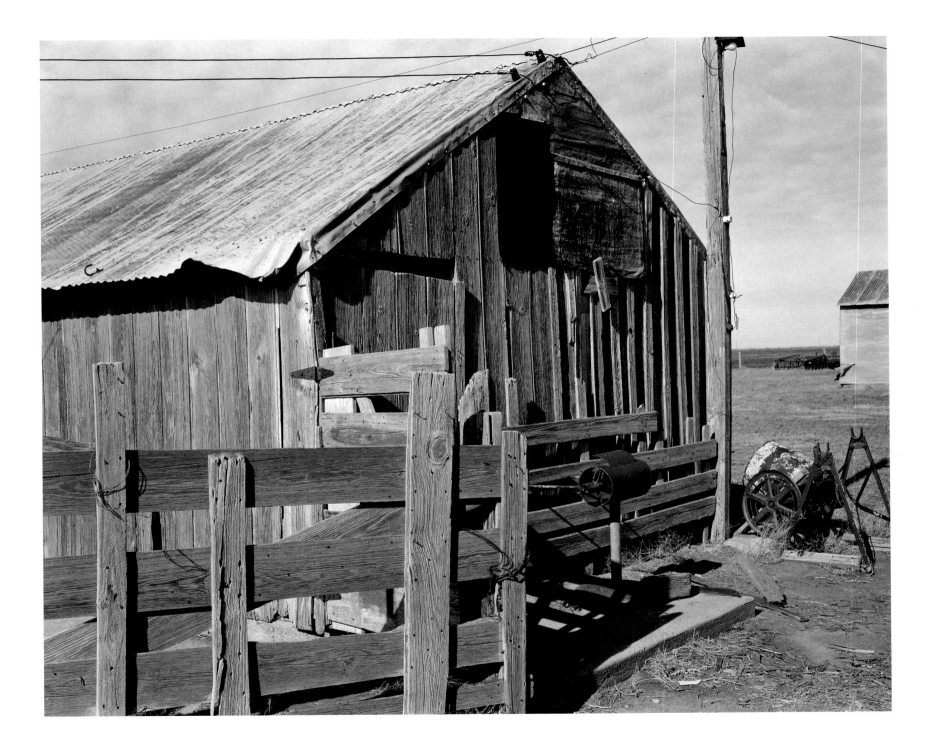

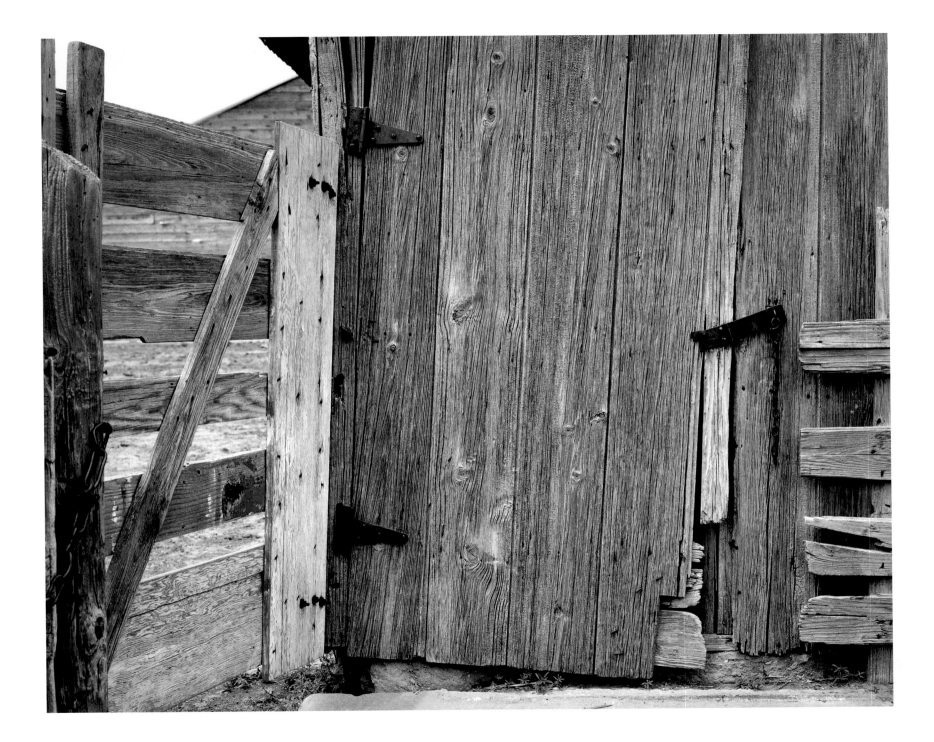

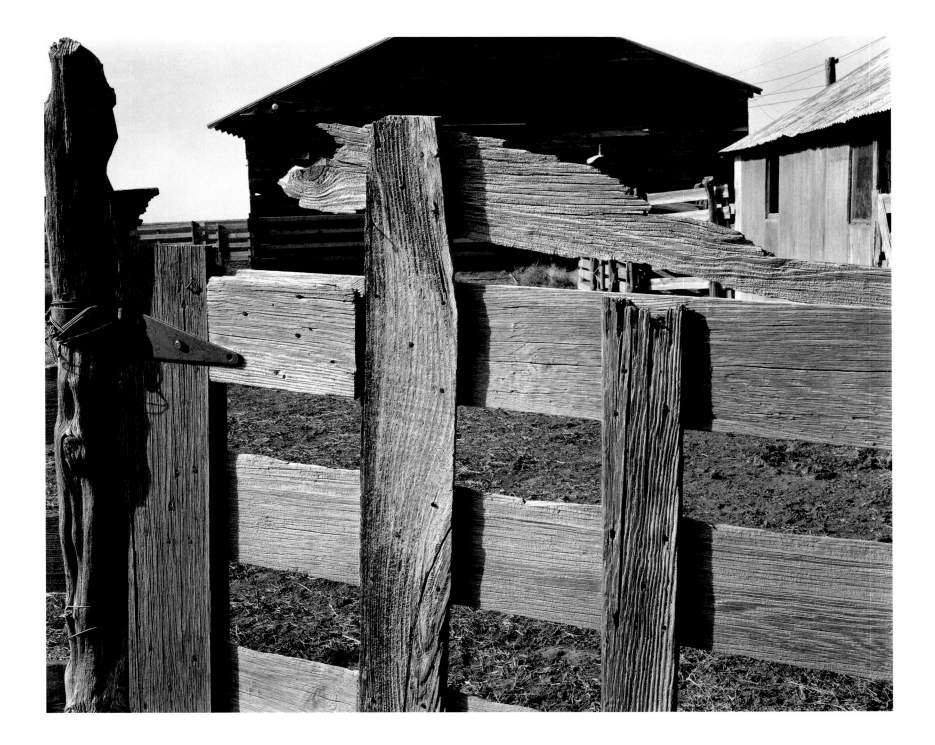

43

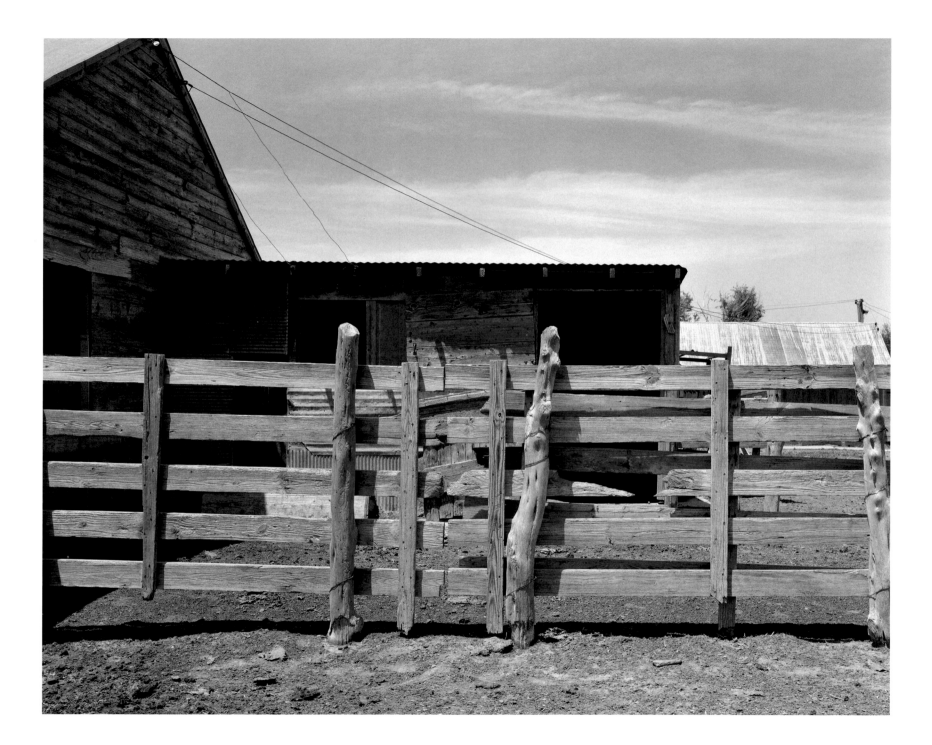

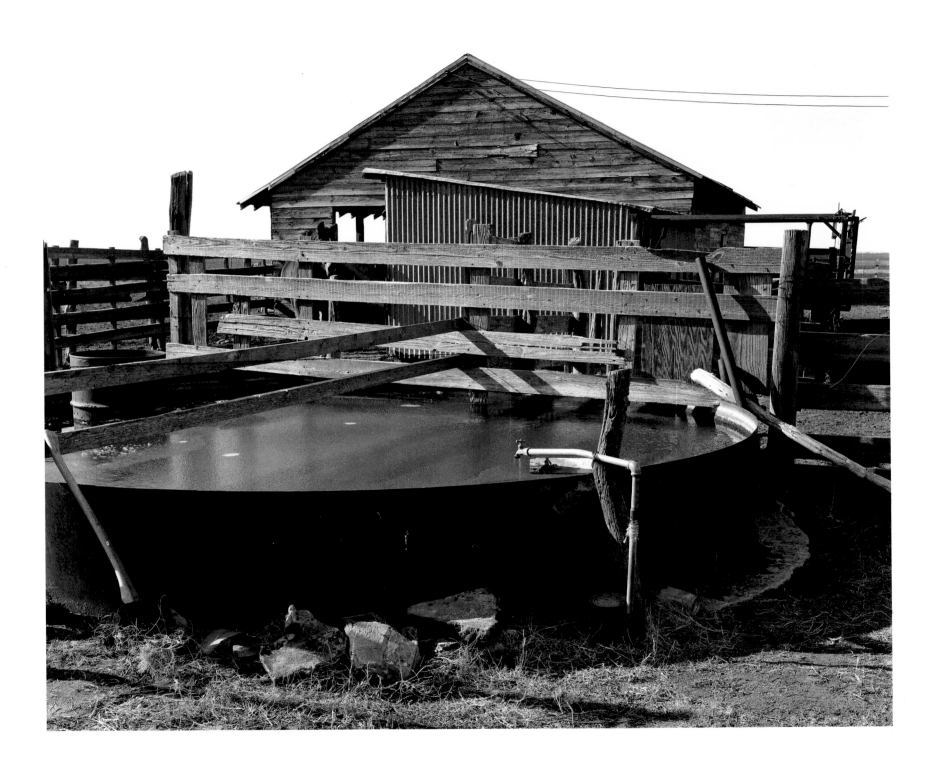

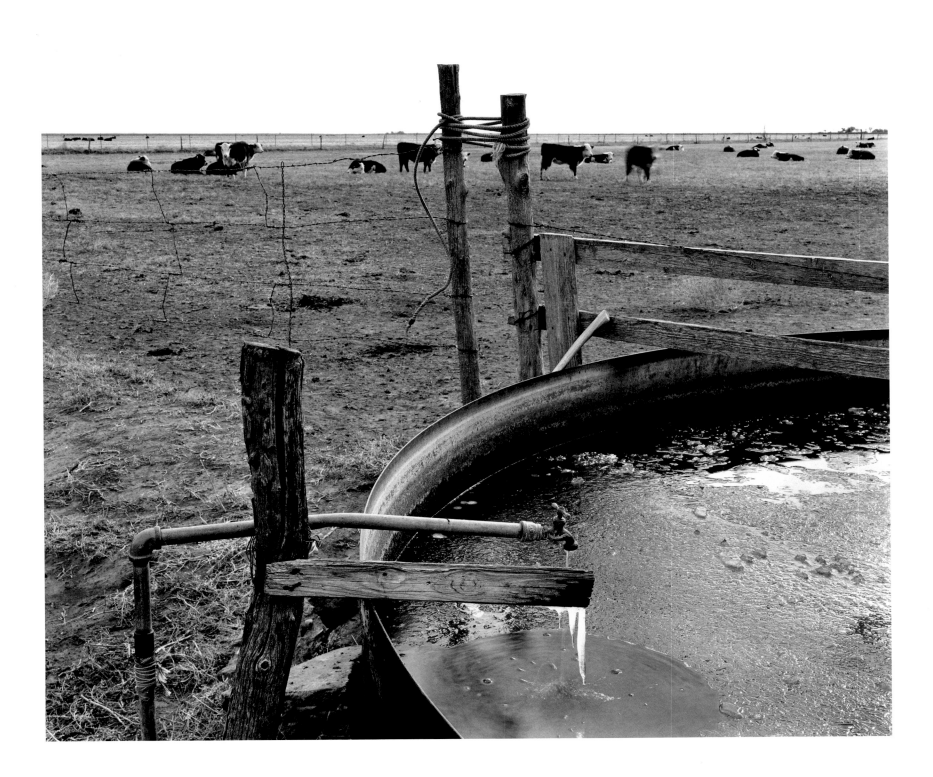

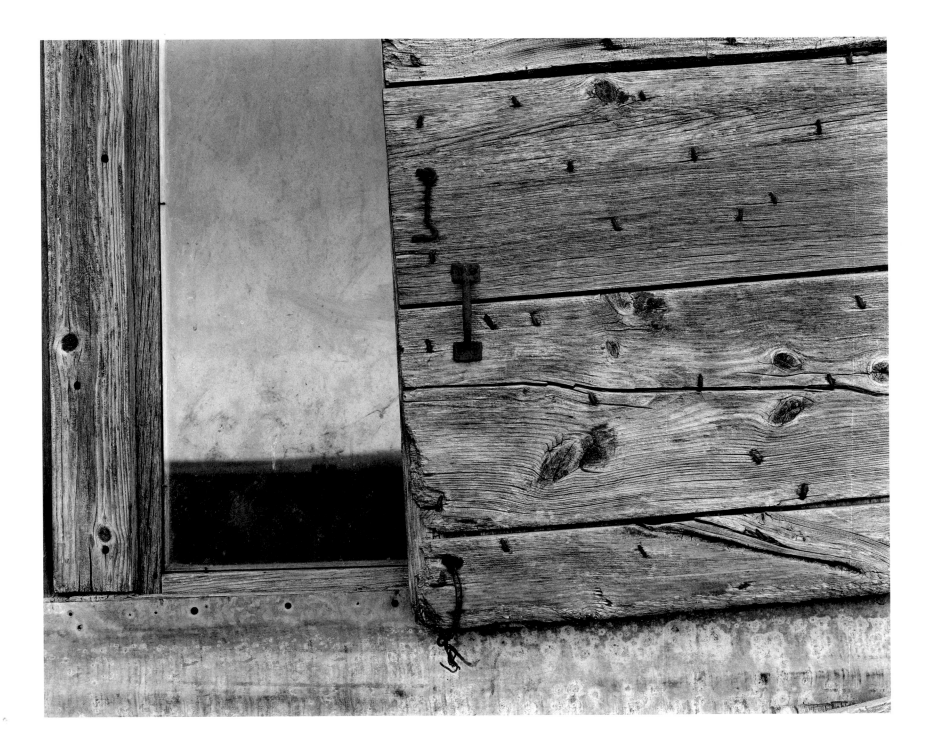

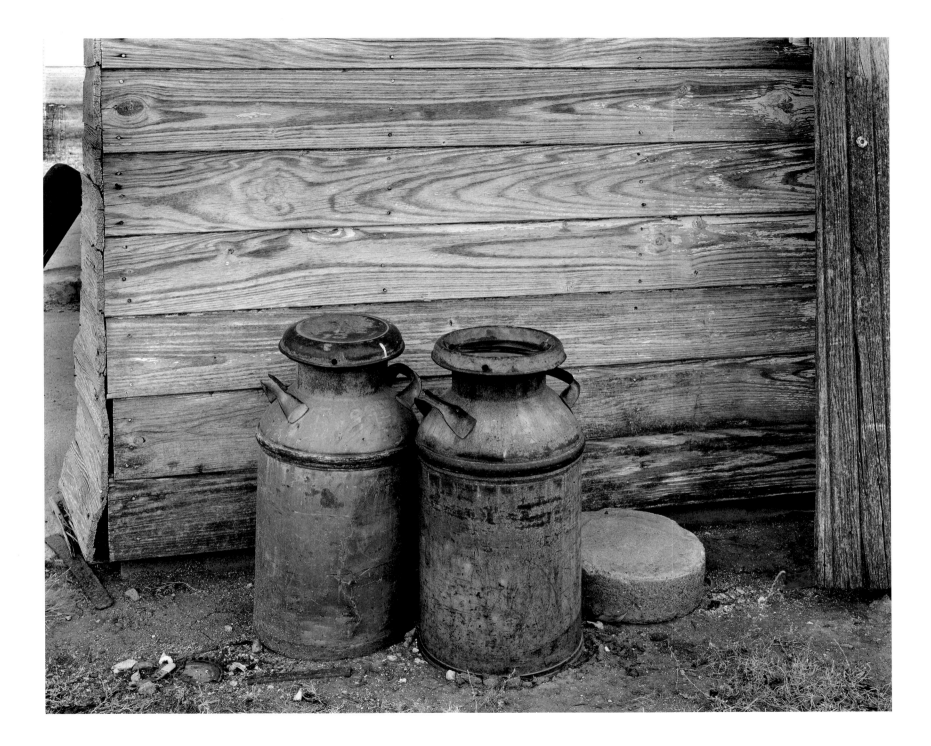

48

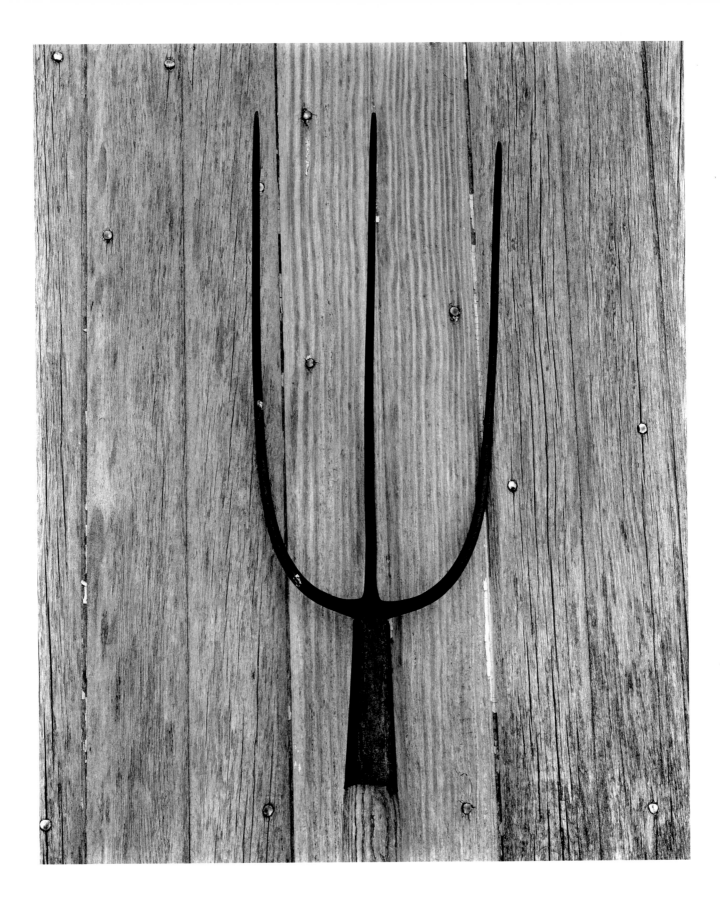

49

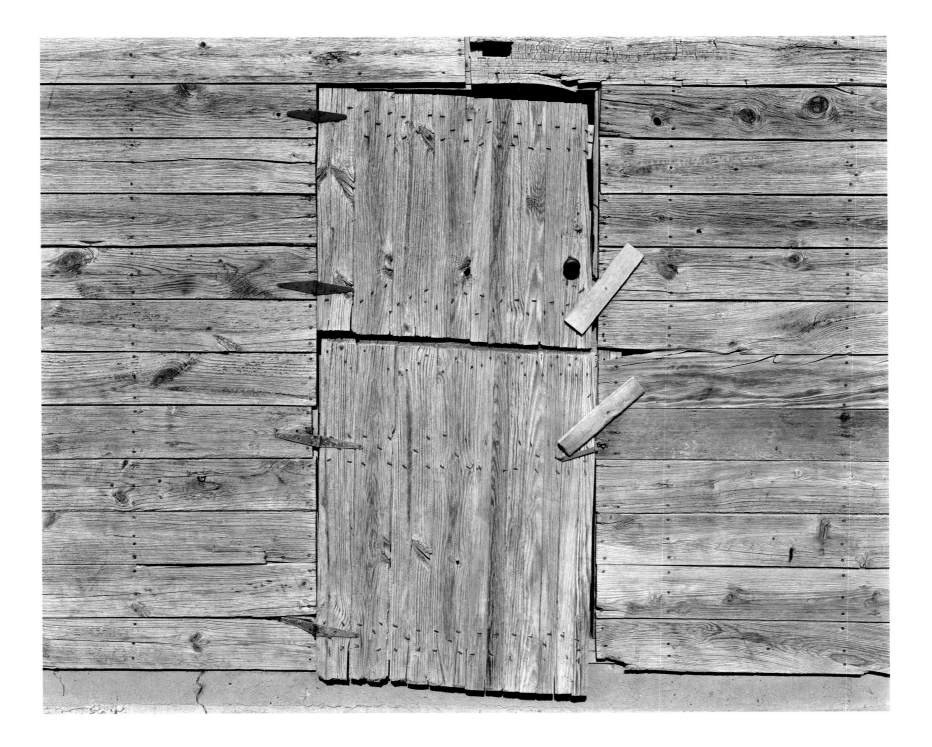

50

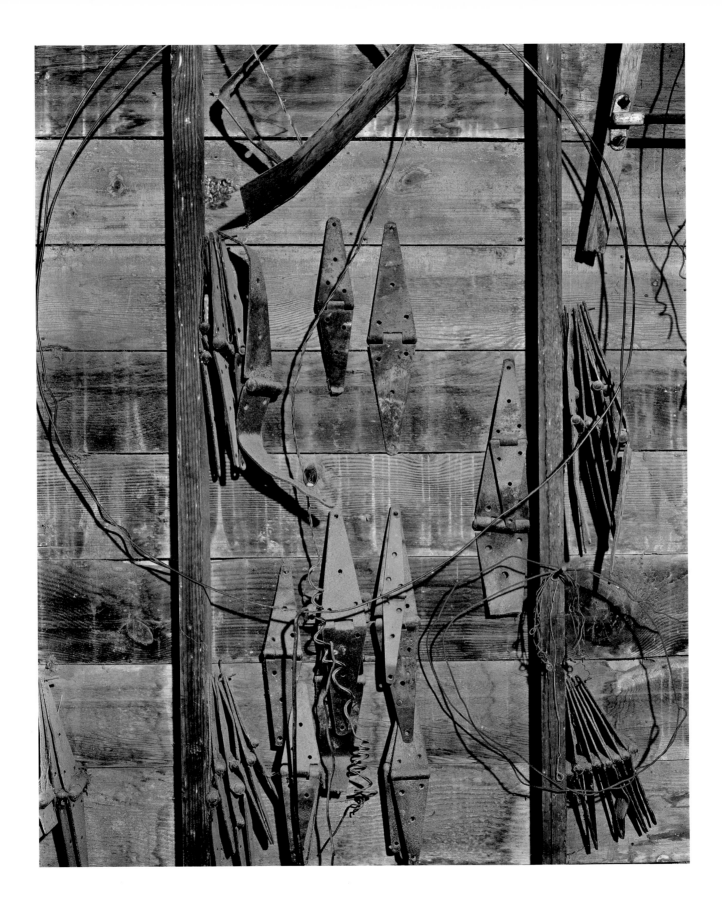

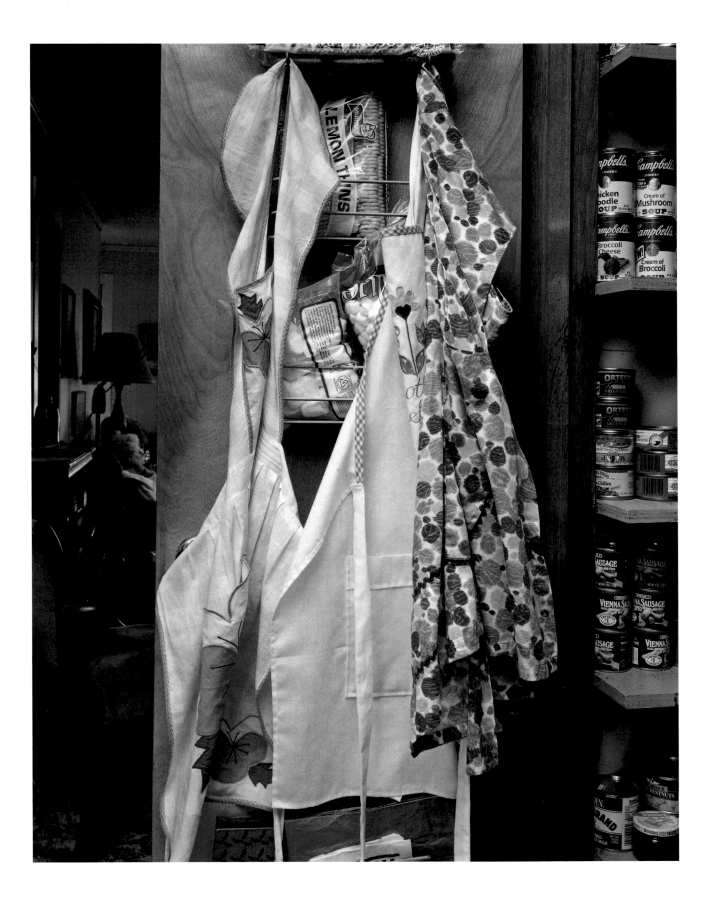

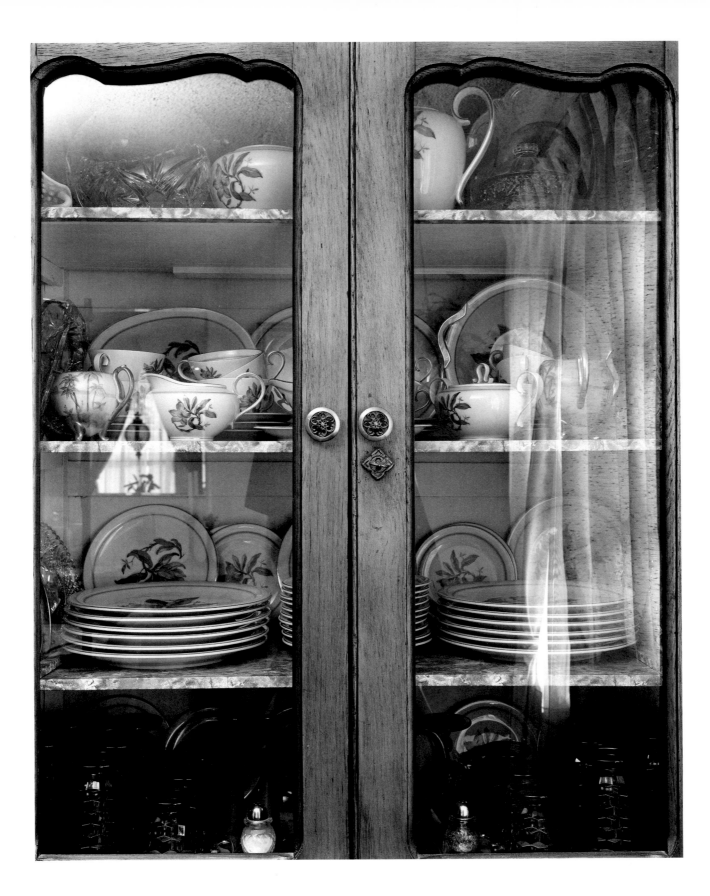

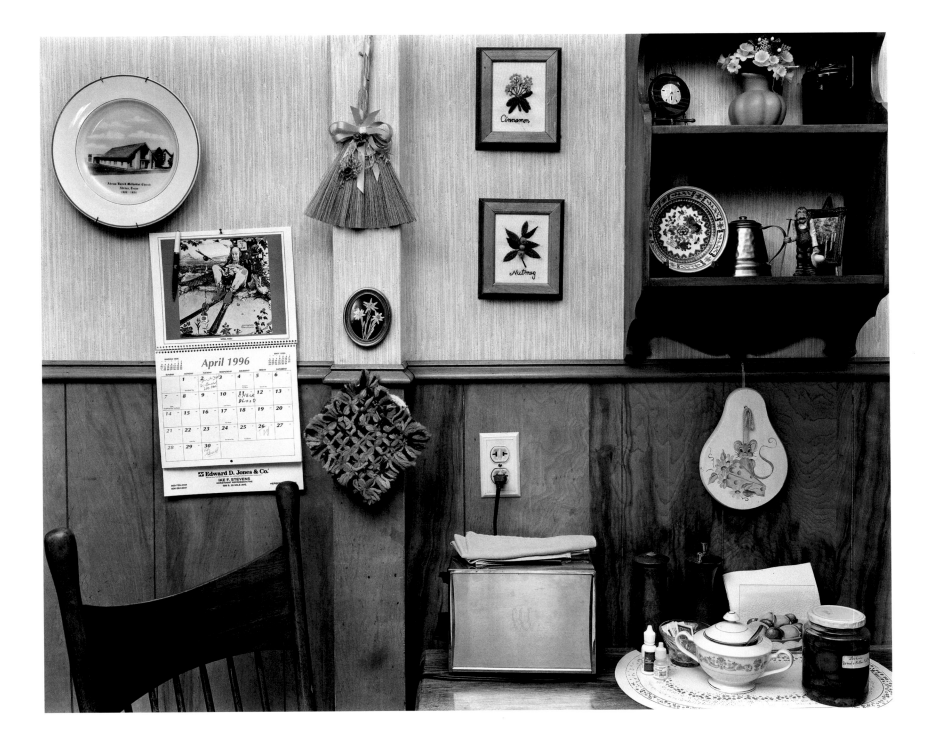

I stood looking out the kitchen windows and saw juncos and sparrows tittering in profusion as they flocked about the winter-barren poplar. The double kitchen windows look southward to the end of our pasture, and on to the next section of the neighboring farm. There once was a lilac bush near these two windows, and its sweet fragrance in spring has made me irresistibly drawn to lilacs ever since. I have a dominant memory of my mother standing at the sink in front of these windows, washing dishes by rote while looking down the pasture toward our cattle and toward the corrals where my father might be moving about. She would be humming a tune, usually one of her favorite hymns.

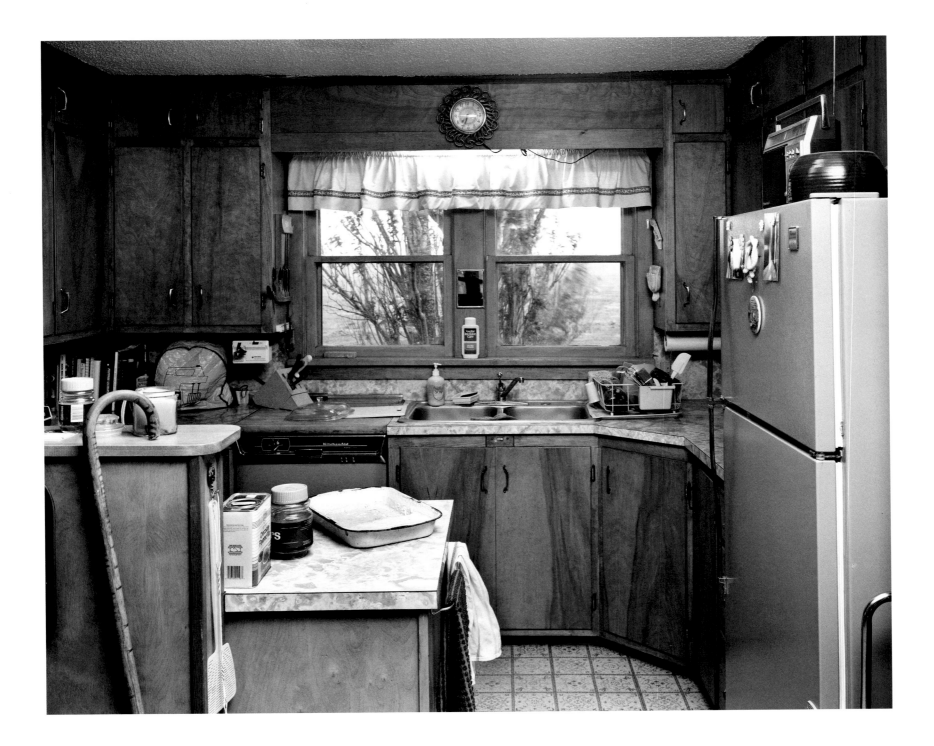

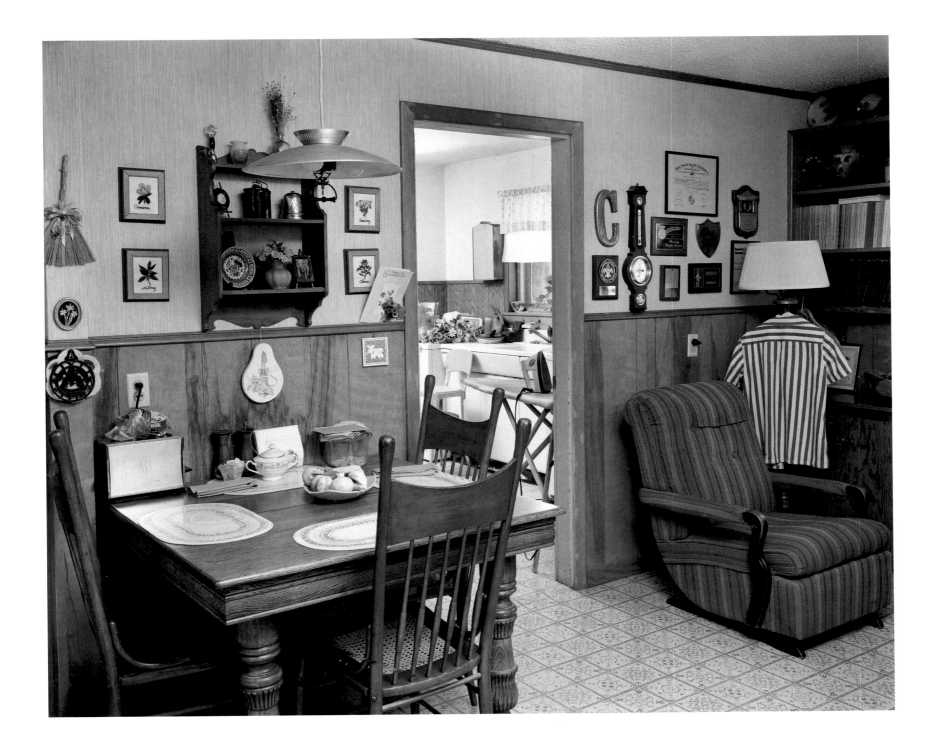

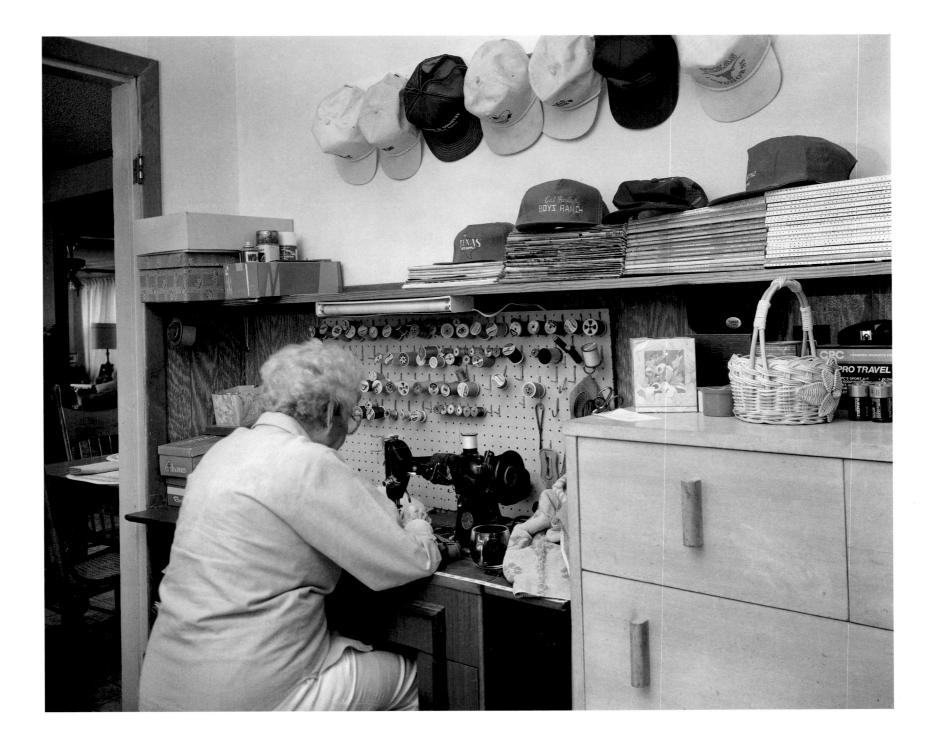

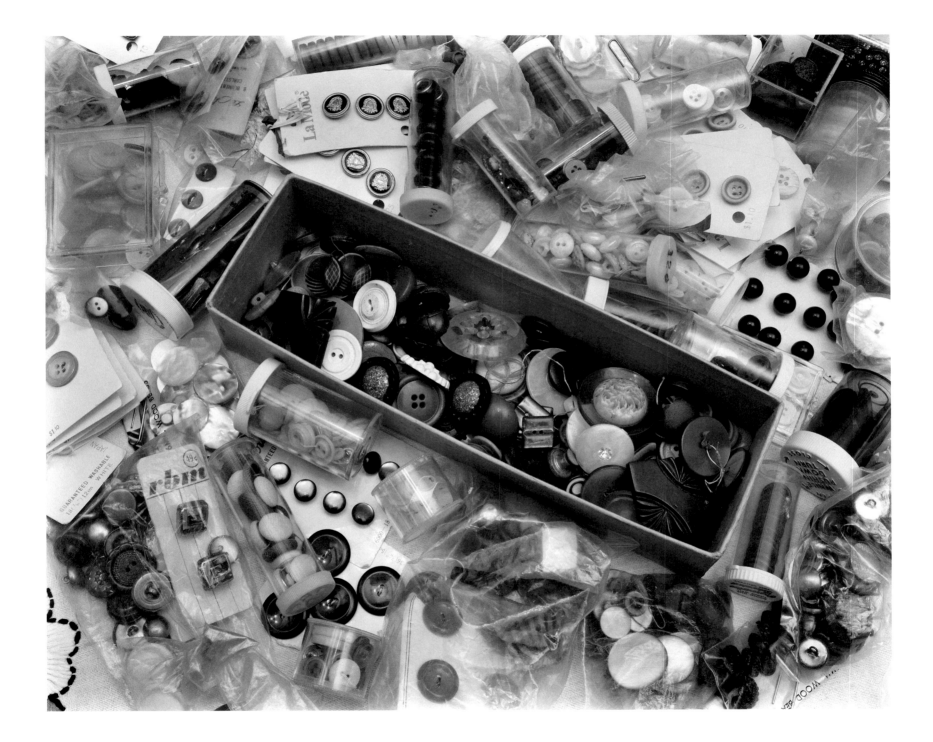

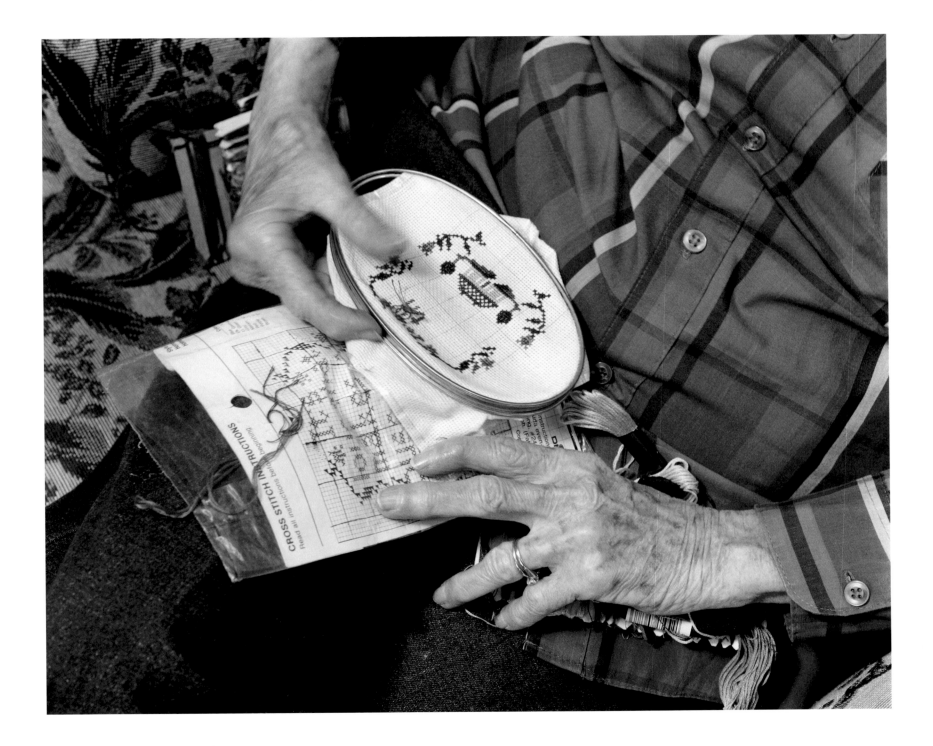

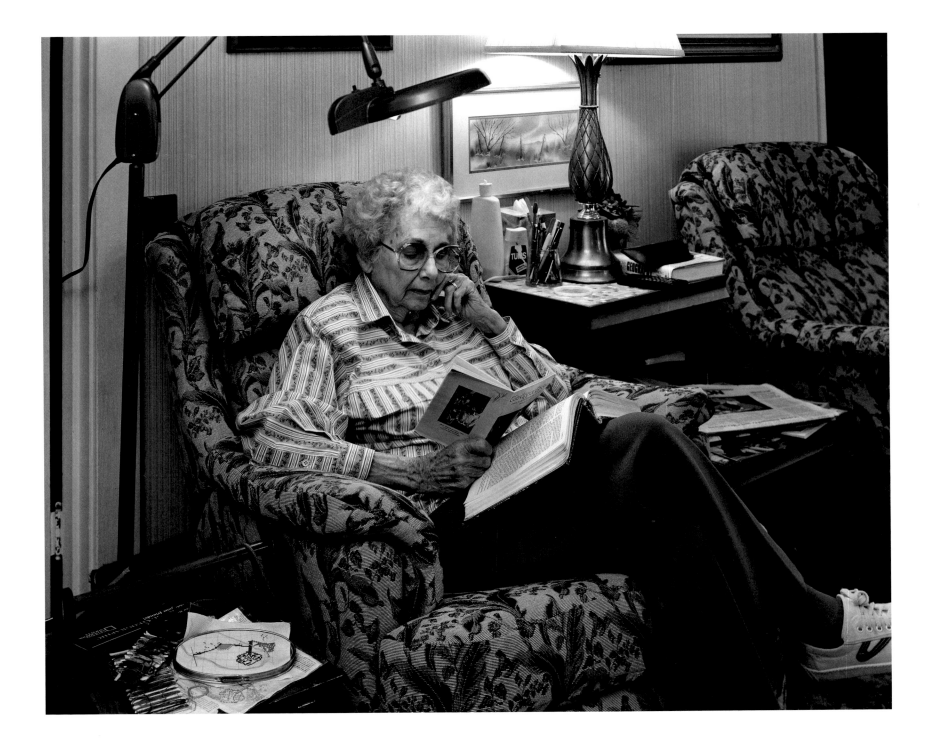

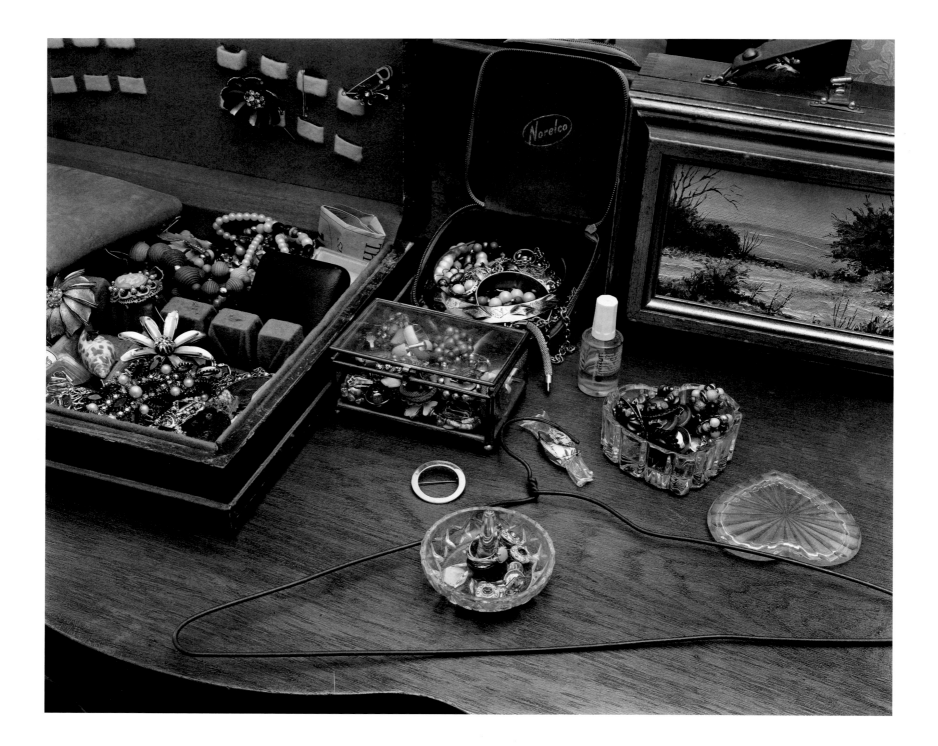

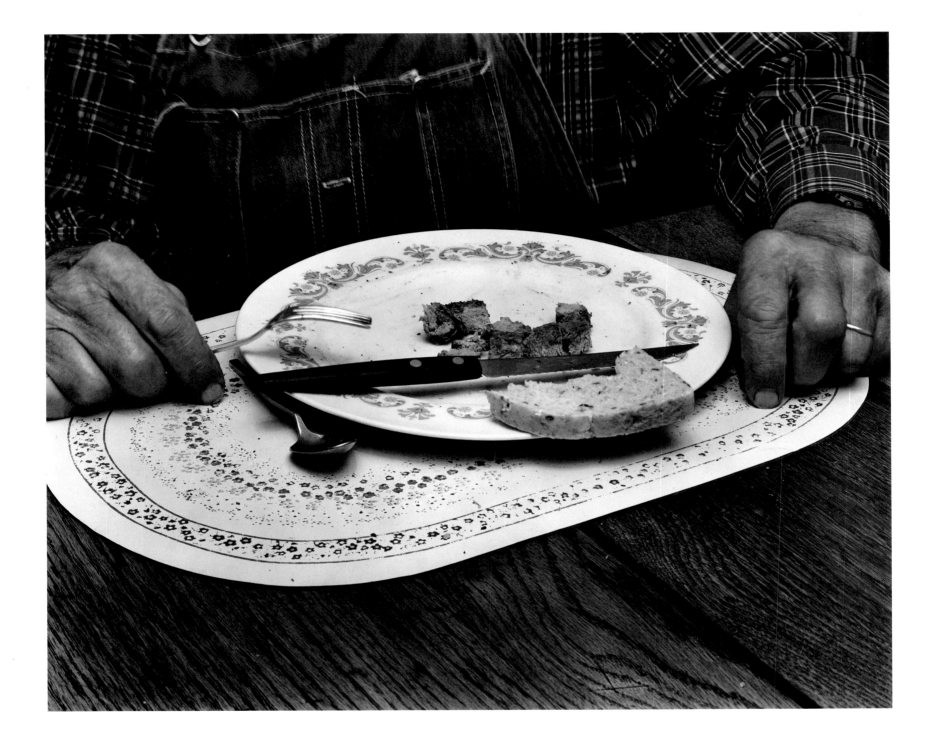

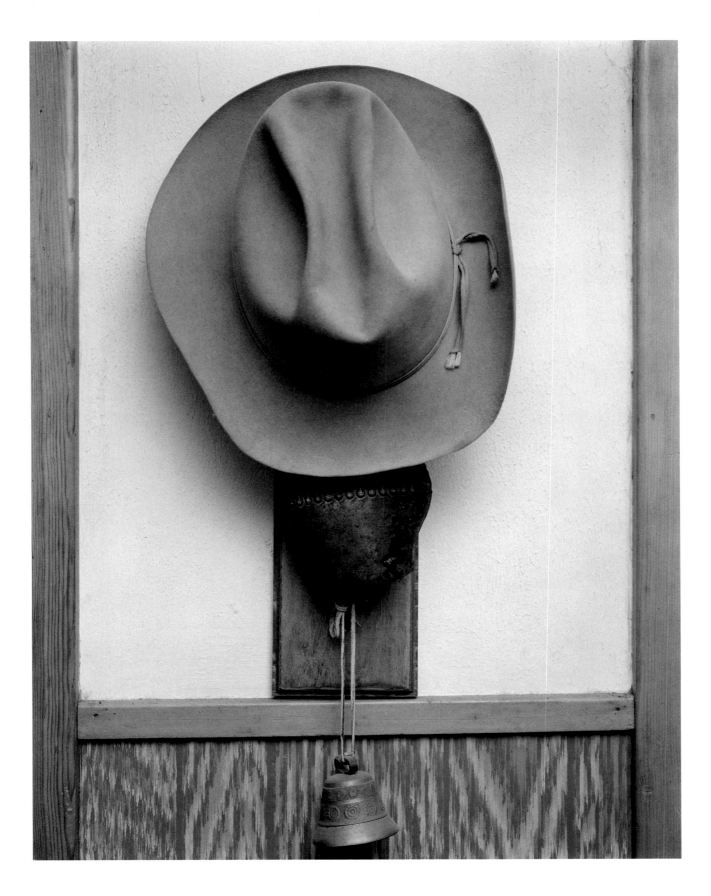

64

Everything has changed, yet everything is the same. Superficial things change—a different wallpaper and some new upholstery, a dead tree removed, a fence taken down. Yet these are temporal changes; they have little or nothing to do with the enduring spirit of the place—a place interfused with a way of living and being.

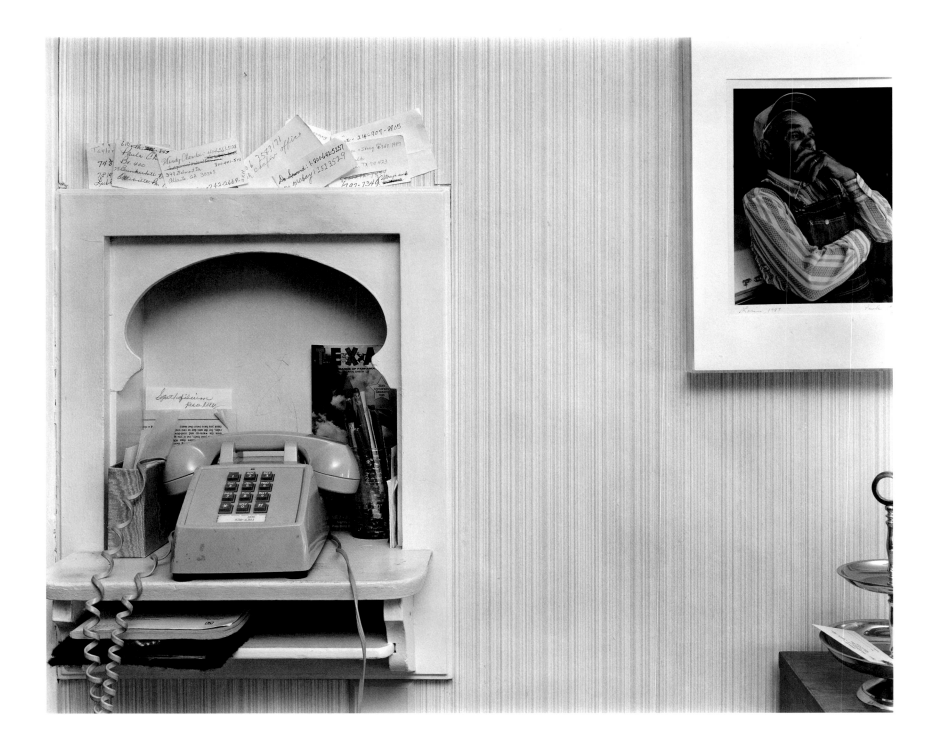

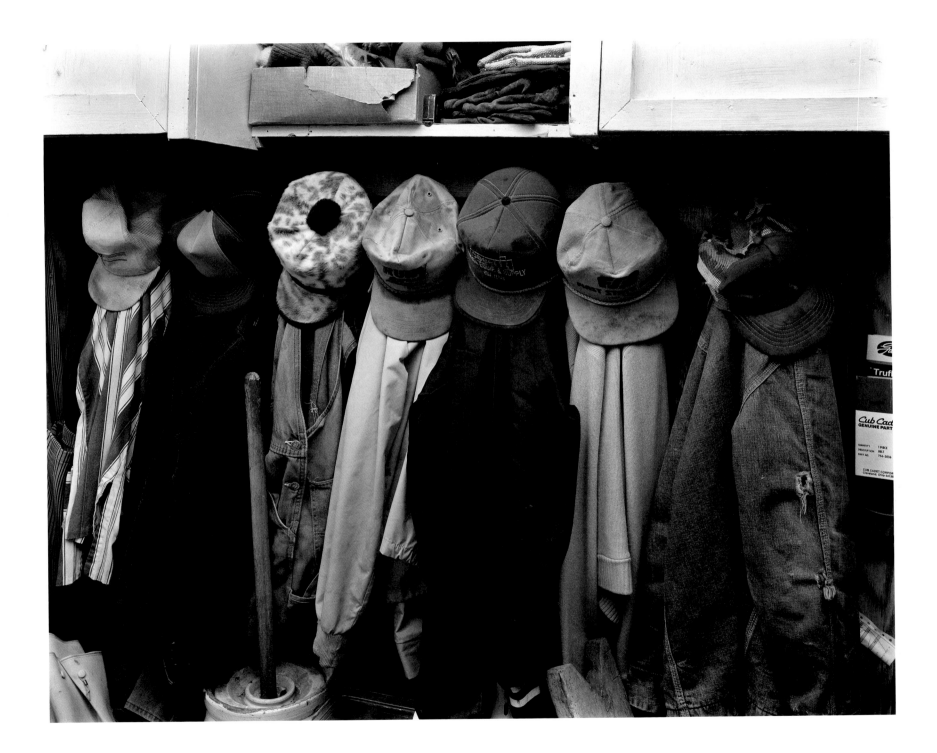

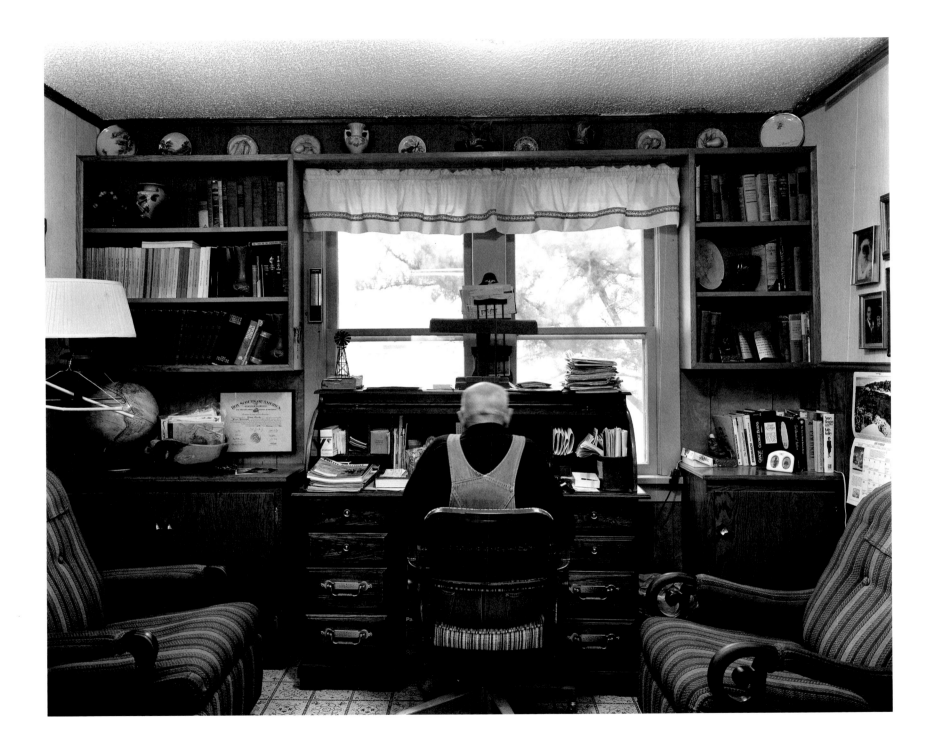

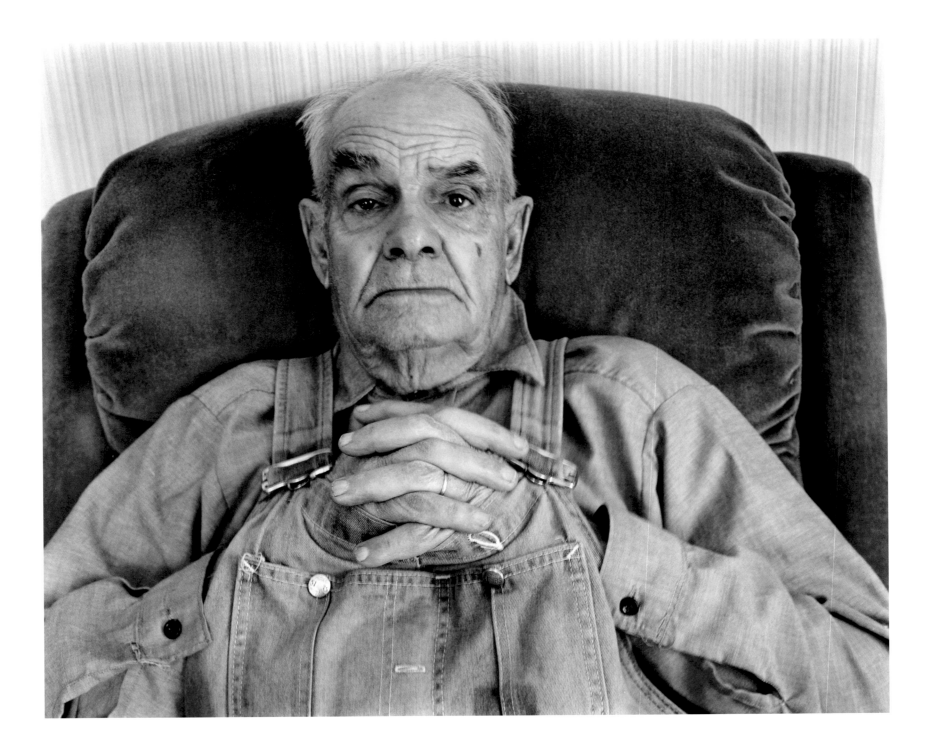

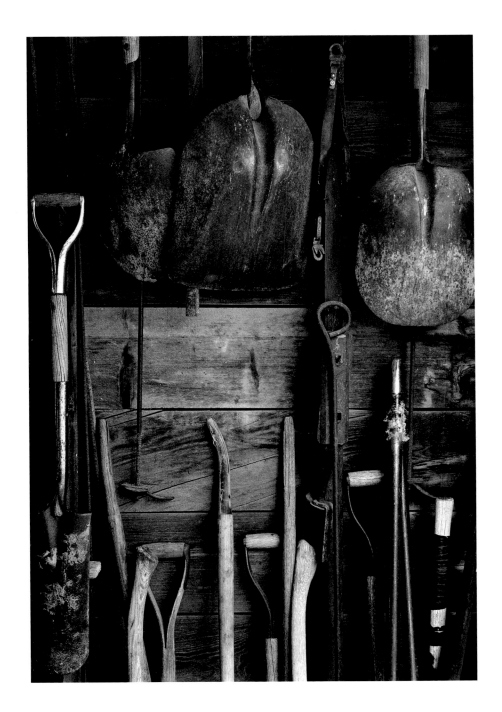

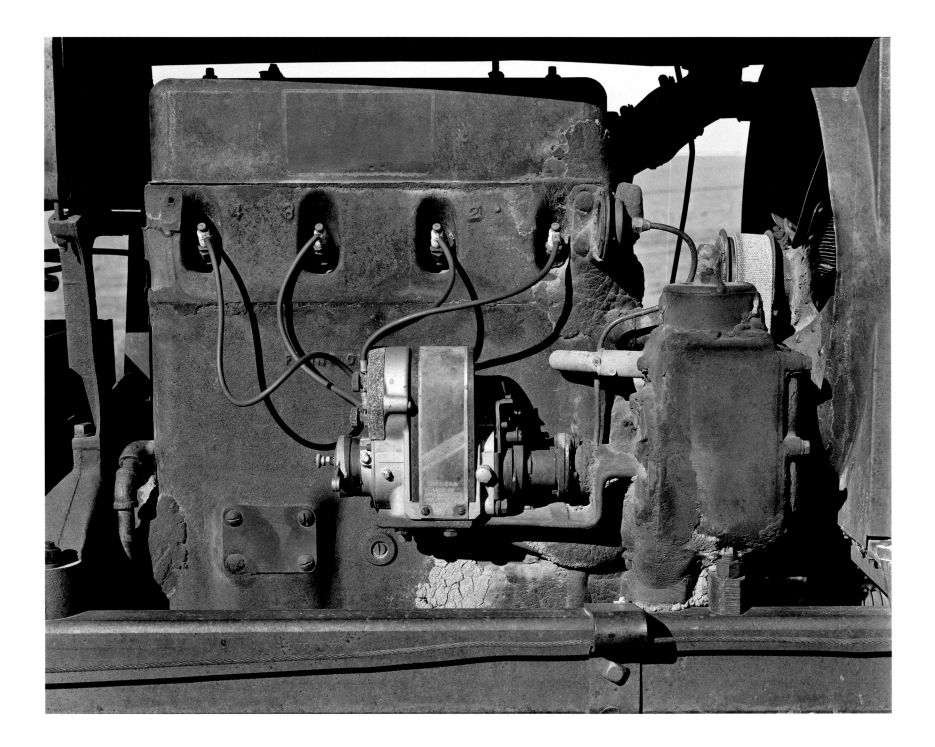

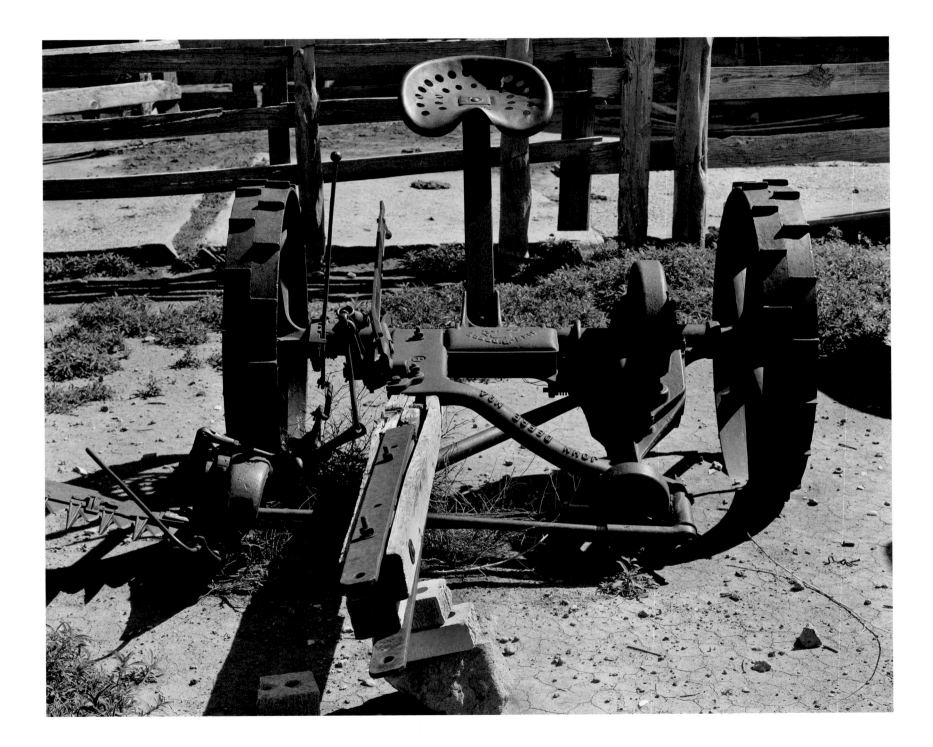

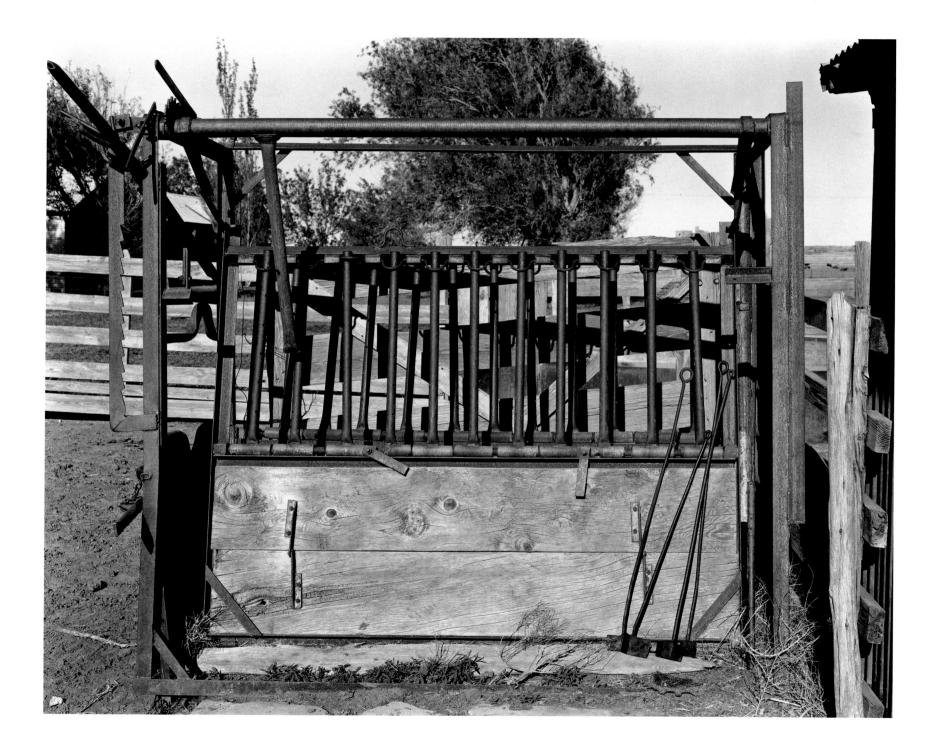

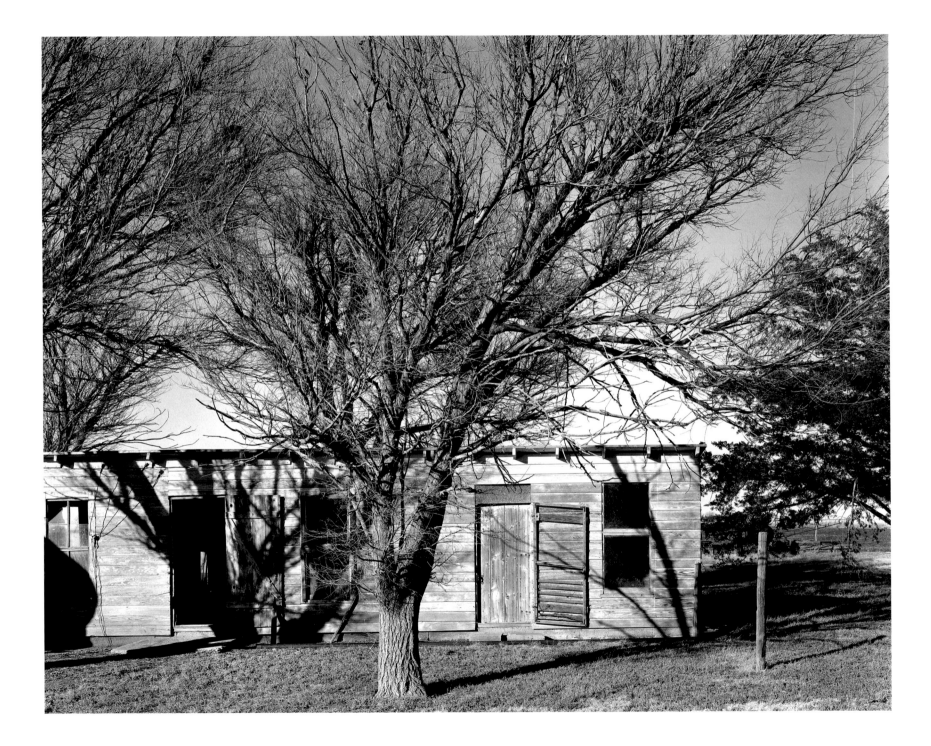

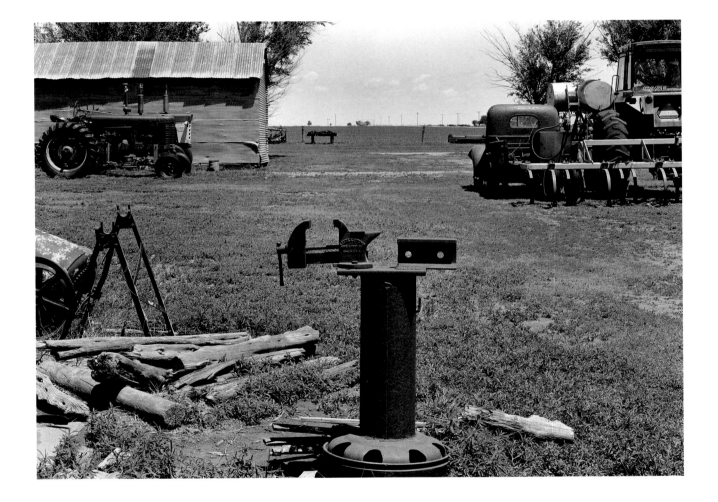

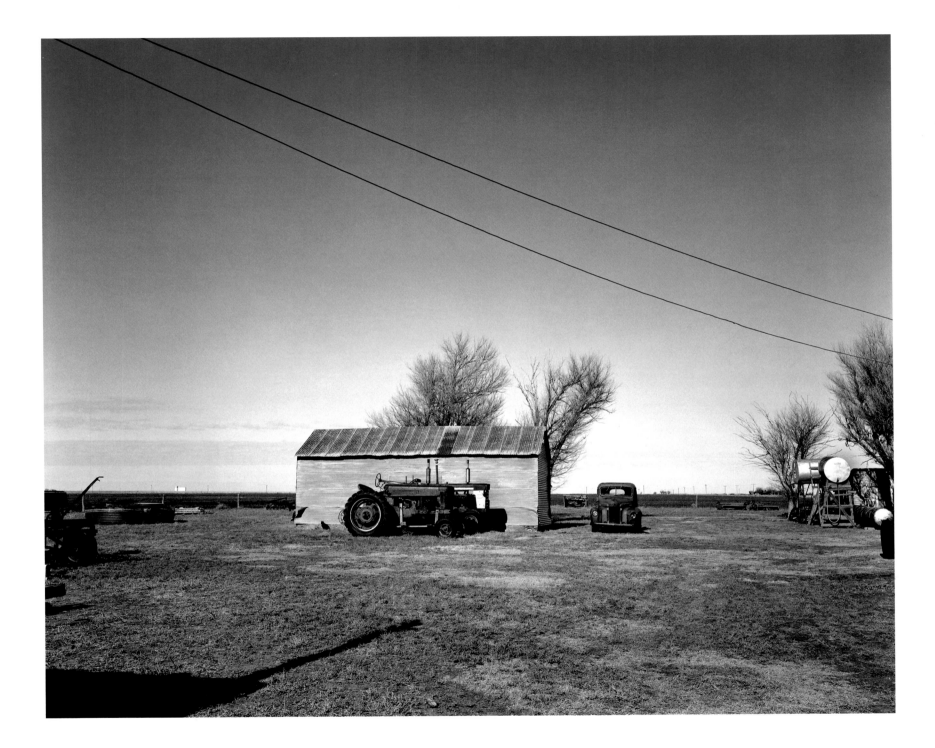

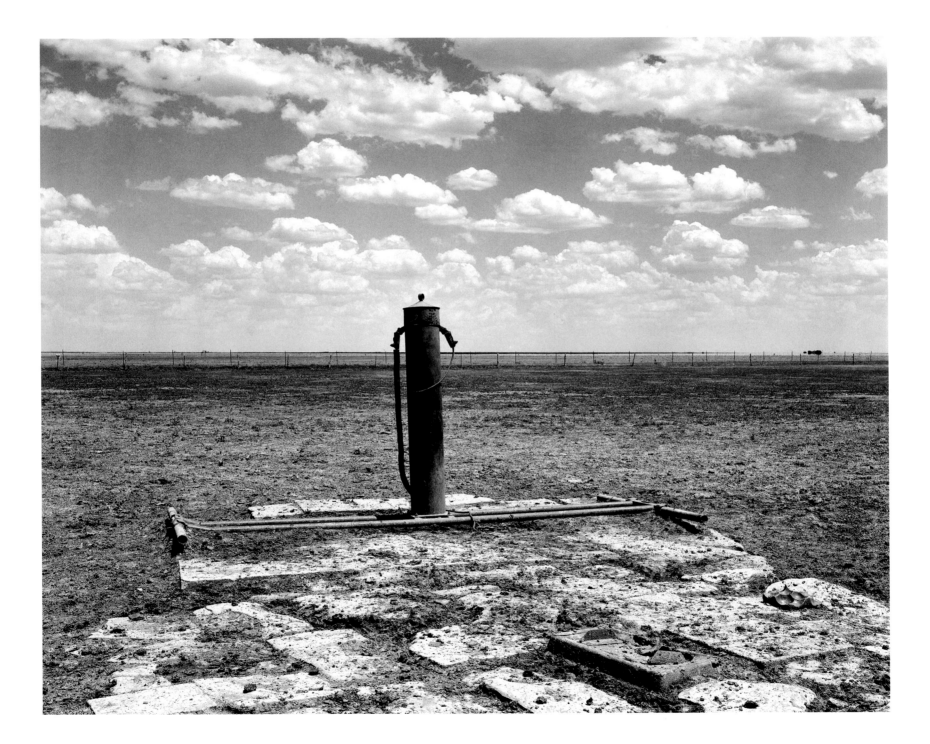

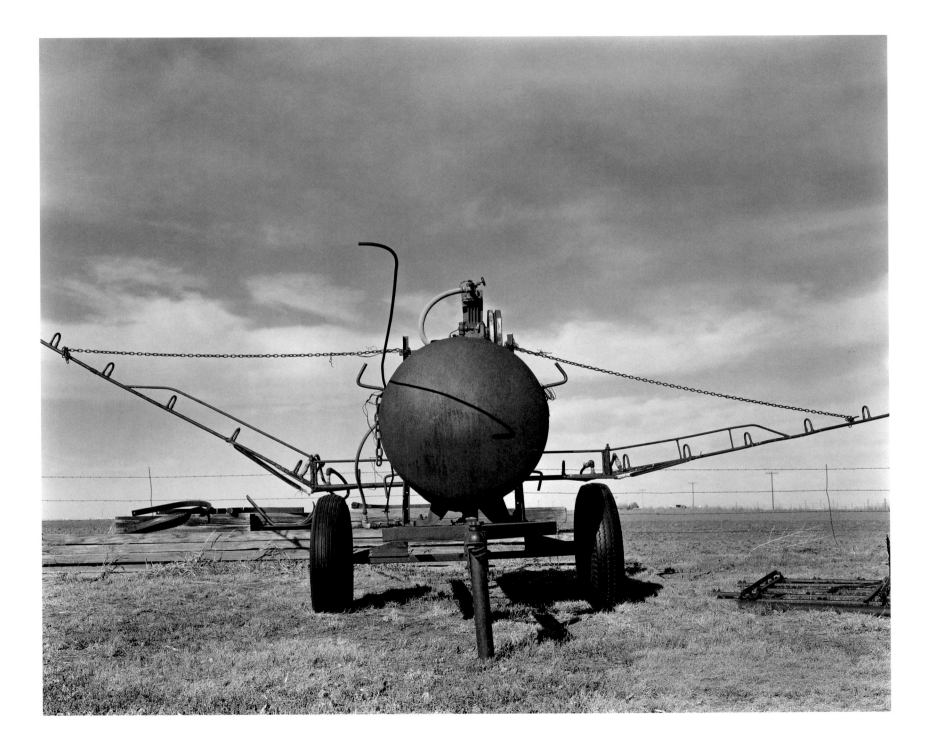

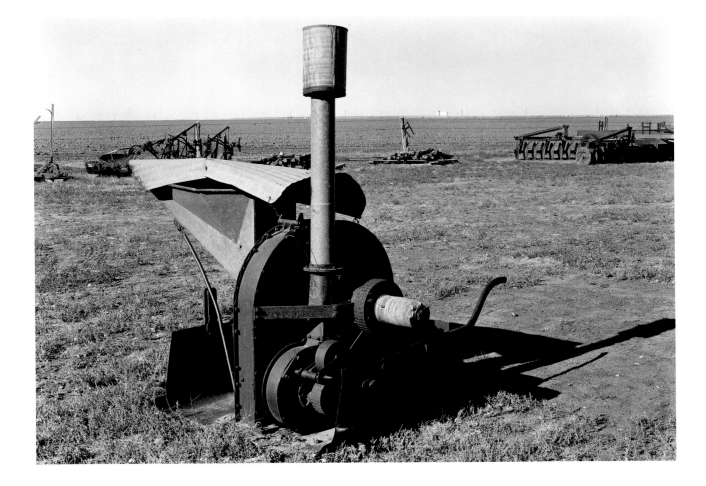

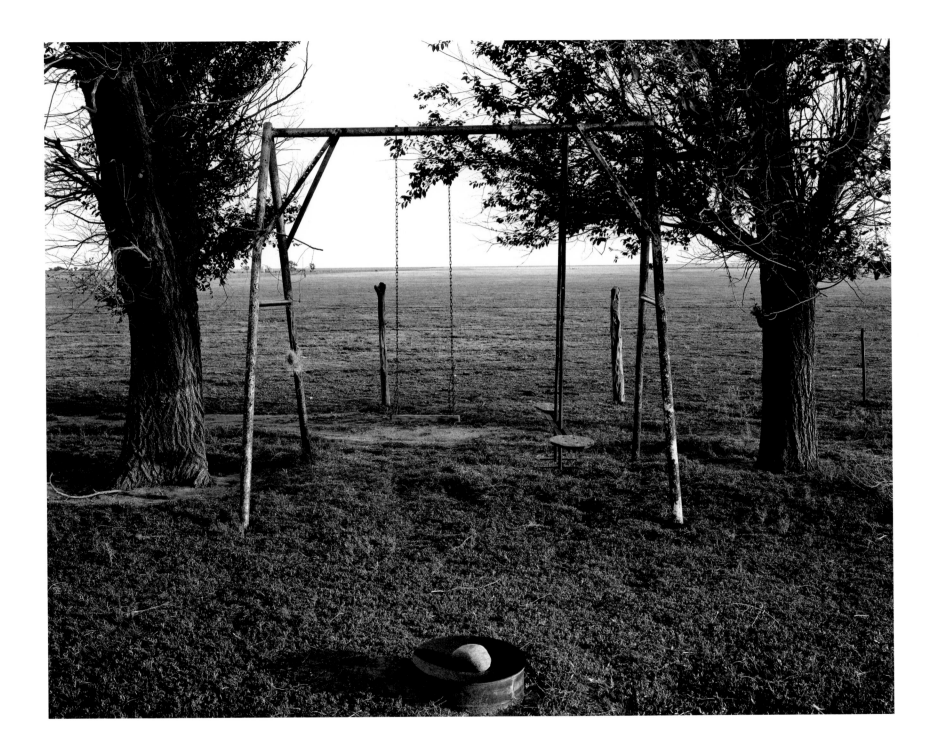

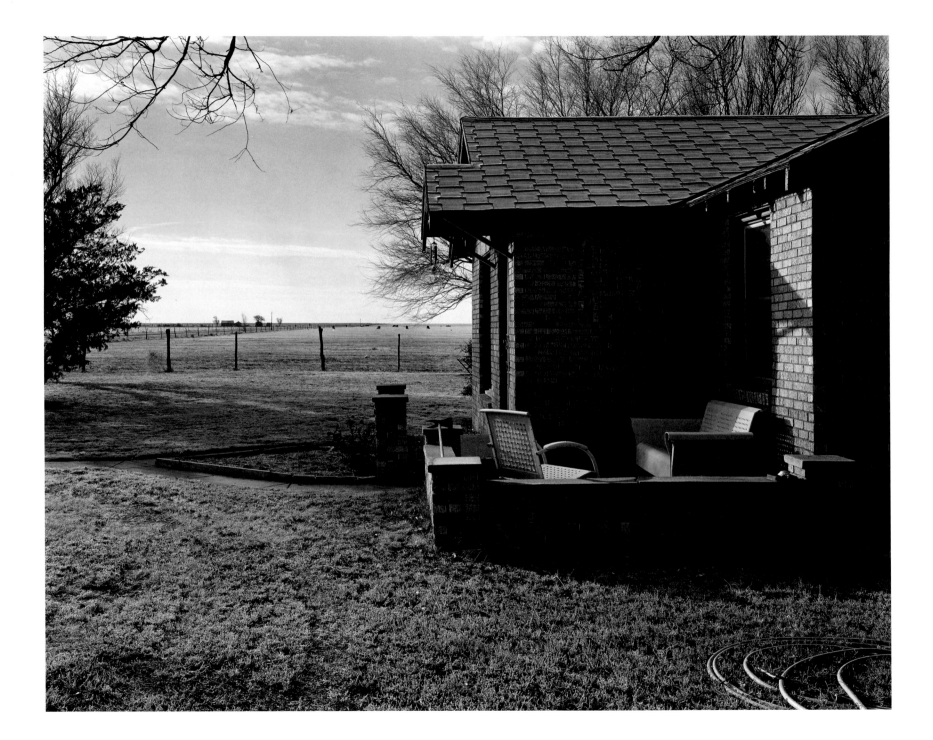

NOTES ON THE PHOTOGRAPHS

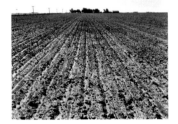

Frontispiece

In October, when this photograph was made, the wheat in these furrows had been planted for a month and was struggling to live—there had been no rain and the winter brought little snow to sustain it. By the end of April, less than two months before harvest, the wheat had died from drought. This year, the fields would yield no crop and bring no income.

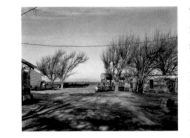

3

The light in winter has a particular clarity and freshness. The arc of the sun is lower than in summer and the shadows throughout the day are crisp and deep. The cloud formations, like those seen here on the horizon far to the north and west, generally originate in the mountains of New Mexico, and as the clouds move eastward and become visible on the High Plains, they often look like mountains themselves.

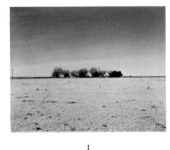

1

The land is flat and open and the atmosphere is so clear that at night you can easily see individual lights in the town of Vega, fifteen miles away.

Those who live in the Panhandle refer to distance in terms of miles, not minutes or hours, and they give directions by the compass. One mile equals one minute of travel time. Like much of the Panhandle, most of Oldham County is laid out in neat section lines, square miles that are aligned with the cardinal points of the compass.

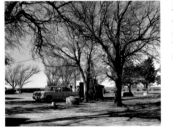

4

My dad is filling a water tank from the well house tank supply. He hauls it to a stock tank in one of his fields where there is no well and where cattle are grazing the young wheat.

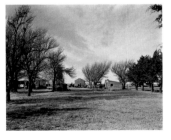

2

The Creitz homestead is on a section of land (640 acres) that my father bought in 1940, the year before he married my mother. For this section, he paid $10,017—far from the inflated price of $27,456 paid for this same section during the land boom of the late 1880s. Over the years, he has added another 460 acres.

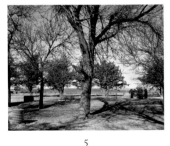

5

The trees on the farmstead are elm, ash, poplar, and cedar. Each one was planted by my dad as none of these varieties grows naturally on the High Plains. Each year, when my parents drove to Grayson County in East Texas to visit my mother's family, Dad dug up a few small red cedars from his in-laws' thickly wooded property, balled the roots with burlap sacks, and hauled them in the trunk of the car 400 miles back to the farm. He said he never lost one of them.

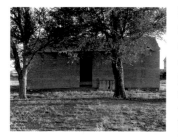

6

During harvest time, this corrugated tin granary and two other wooden ones were used to store most of our grain, both the wheat and a grain sorghum called maize. When my dad got much older and phased out his livestock, he stopped growing maize and each year hired a combine crew to haul all the wheat to the grain elevator in Adrian. When my brother, my sister, and I lived at home, we were the "hired hands" for all the grain harvests. This granary now houses only a few odds and ends. The two wooden granaries have been torn down.

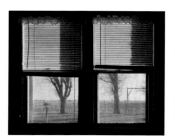

7

The homemade swing is the one I used as a child. My dad has renewed the seats a few times, but the frame is unshakable. The swing remains in the back yard long after the children and grandchildren have grown up, but it is available for any small visitors.

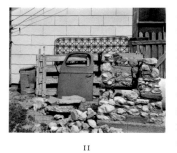

8

The windows from my sister's former bedroom look past the swing and through the elms toward the south pasture. Before an addition to the house that converted this room to a bedroom, it was a work room that housed the wringer washer, a cream separator, a work sink, and a table on which we butchered our own cattle and hogs for the season's supply. The windows are all that remain from the original room.

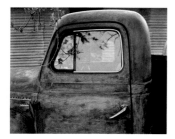

9

The 1951 six-cylinder International truck is one of the few vehicles on the farm that was bought new. Originally shiny bright red, it now has the patina and color of oxidized metal. It has been used mostly for hauling wheat, maize, and other grain crops, and for hauling hogs and cattle to and from market.

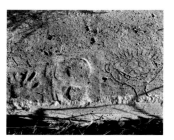

10

Every foundation on the farmstead has been poured by my father. Whenever he poured concrete for the sidewalks, the garage, the barns, or other outbuildings, we children scratched our names and ages in it. Sometimes we even drew pictures of ourselves. This drawing by my brother is imbedded in the foundation of the now empty hay barn. Alongside his imprints and his drawing, he also spelled out his name and age—"Terry Lynn, 9 years old." My brother died in 1992, shortly before his fifty-first birthday.

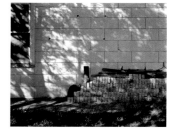

11

My parents seldom throw anything away. The caliche stone structure is the remains of a barbecue pit that my father built when my brother and I were small. People don't cook out much in this part of the country because the wind blows all the time. It is an effort to keep a fire lit and controlled, to keep the sand and dirt out of the food, and to keep the food from blowing off the grill. I can remember the excitement of cooking out on this grill for the first time, but I don't remember its getting frequent use.

12

These leftover bricks have been neatly stacked beside the garage wall since 1962, when the last addition to the house was completed. The first renovation began in 1941, when Mom and Dad married and moved into the original tiny stucco house and added an indoor bathroom, small bedroom closets, and some cabinets for the kitchen. By 1945, they added two rooms onto the back of the house, and in the late forties, after another addition, they bricked over the stucco.

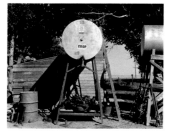

13

Two tanks for diesel fuel were installed in the seventies, a convenience for fueling the farm trucks and tractors. Some plow sweeps are stacked beneath the tank in the center, and the former chicken house is behind.

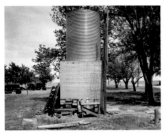

14

The well house was built to store the water pumped up by the windmill. Originally, the well only pumped about a gallon a minute, so Dad hired a well driller to dig deeper, and in 1951 he installed a submersible electric pump that brings the water 520 feet up from a good well. It produces about five gallons a minute, and the water is stored in the tank. Windmills are rarely in use nowadays in the Panhandle, and then only for livestock watering rather than for personal use.

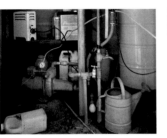

15

Inside the well house, a heat lamp and a small gas heater prevent the pipes from freezing in winter.

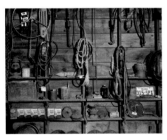

16

There is very little on this wall in the garage that doesn't get re-used sometime, somewhere. The measuring wheel is used for accurate measurement of acreage for a variety of purposes. Under the government's farm subsidy programs, such as the recent Conservation Reserve Program, farmers are required to measure and verify their allotment accurately, confirming that they have not planted more than they are allowed.

17

The basement is the repository for the canning jars, all kinds of old containers that may come back into service some year, and old financial records. It was often my job to "hop down to the basement because you're young and agile" to find a particular jar and then go through the big box of lids to find the right fit. That box of lids was daunting.

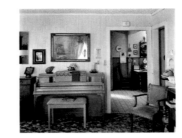

18

I am the only one in the family who took piano lessons. I muddled through seven years of lessons, learned to play a few things fairly well, and played the piano for church on occasions when the regular pianist/organist was sick or out of town. How I dreaded those occasions. I was always nervous about making mistakes at the keyboard before an audience.

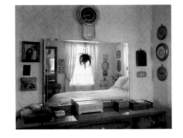

19

My parents' bedroom is brightly and warmly lit by the morning sun. Before an addition was built onto the house, Mom kept her sewing machine in this room. As a child, I spent many hours there watching her sew.

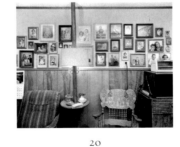

20

The pictures of the children and grandchildren at the many ages and stages of development—from infancy to early school years, from graduations to weddings—have changed position only when they were moved closer together to allow for additions to the gallery or to permit new wallpaper hangings. As I look at these pictures, I am reminded of each of the dresses that I wore to the portrait studio, very beautiful ones handmade by my mother.

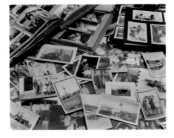

21

We never owned a particularly fancy camera even though my parents made loads of snapshots during their courting days and the children's growing up years. Mom and Dad bought a 1941 Kodak box camera the year they were married. I remember this old box camera and where it sat on the closet shelf, and I recall the distinctive sound that it made when each exposure was advanced.

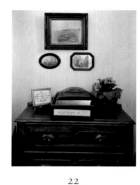

22

The picture at the top dates to circa 1890, when my paternal great-grandparents and other family members posed with eight teams of horses in front of buggies, carts, and wagons on their farm in Deep River, Iowa. The portrait of the farm also proudly displays some cattle and hogs. The counted cross stitch sampler on the chest is one of hundreds made by my mother.

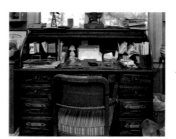

25

My dad's roll-top desk is always left open. He often sits there to deal with accounts, records, and other paperwork, and to read the farming magazines and journals. He has always thought his desk space is pretty well organized and certainly neat enough; my mother has always thought it is a mess.

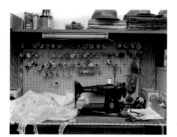

23

This corner of my parents' bedroom displays more family pictures. In the corner by the bookshelf are boxes of yarn that my mom uses in doing needle point and making afghans.

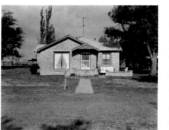

26

Mom and Dad in their easy chairs. Among her many other household tasks, my mom spends many hours in "her" chair doing hand sewing. And this is where they do most of their reading.

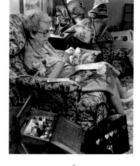

24

Mom had a treadle-type sewing machine before she bought this Singer in January of 1945. This was one of the first cabinet models that came out after Singer's production lines were no longer devoted to the war effort. Mom has used it continuously since that time with seldom any mechanical problems.

As a child, I frequently accompanied my father to the Farmer's Grain Cooperative to buy chicken feed so that I could pick out the patterned feed sack I wanted for making something—a dish towel, a pillow case, an apron, or even a dress if I could find a really nice pattern. Fabric was scarce after the war, so the milling companies had the idea of making a fairly good grade of cotton available in this way. I remember a lovely one dotted with tiny blue flowers on a field of soft yellow, and I particularly remember the resulting sun dress.

27

The front of the house. There once was a front gate where the cement walk ends. It was connected to a post-and-wire fence next to a semi-circular driveway paved with caliche. I had known this arrangement for so many years that I thought little of it when the fence and gate were taken down, and I didn't notice at all when the caliche driveway disappeared beneath an overgrowth of pasture grass. Even when the only remnants were the walkway and the solitary gate post that still holds the all-essential rain gauge at the end of the walk, I didn't see it as a walkway that just ends, going nowhere. I was still thinking of the arrangement the way it used to be. I began to realize that my past experiences had altered my perceptions of present reality.

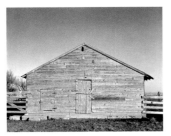

28

This feeder barn allows cattle to come into it from the open pasture on the right or from the corral on the left. The small opening just beneath the gable was designed to accommodate a feed grinding operation. Bundles or bales of hay from the nearby hay barn are fed into the feed grinder outside the feeder barn. Activated by a belt pulley on a tractor that in turn activates a blower, the feed is carried up through a four-inch pipe that funnels the feed into a bin on the inside. There it is dropped into the feed trough that serves both sides of the barn.

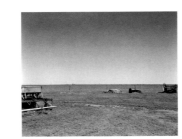

32

To the northwest, the Adrian Wheat Growers Grain Elevator is in the center of the horizon, about three miles as the crow flies. On the left is a 1936 shovel-type Dempster wheat drill; to the right of the fence post pile is a 1930s dirt mover called a "Tumblebug," bought second-hand in 1940.

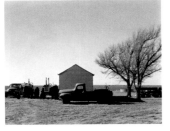

29

The 1945 six-cylinder International pickup belonged to my paternal grandfather. It came into service on my parents' farm after his death in 1968. With my dad's careful maintenance, it continues to run quite well, but not fast.

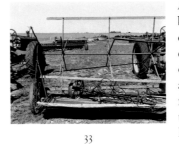

33

Although no longer in use, this 1936 John Deere broadcast binder was used to cut and bundle hay crops. It was also used for cutting and bundling row crops such as milo. "Broadcast" crops are planted closer together than row crops and are evenly spread as they grow. Row crops are generally planted forty inches or more apart and have space between the rows when harvested. Such crops were usually harvested with "row" binders. Binders went out of production many years ago, and nowadays swathers and bailers perform this operation.

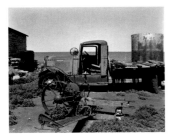

30

I learned to drive on this 1935 International truck when I was nine years old. It has both a hand crank and a starter on the floor. I was not strong enough to start it with the crank. But the crank was needed only when the battery was low. I was too short to hold down the floor starter and see over the steering wheel at the same time, and I could barely see over the steering wheel with my foot on the gas pedal. The sickle mower in the foreground could be pulled by either horses or tractor. It was bought by my grandfather in 1935.

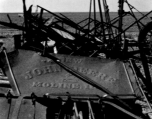

34

Another view of the 1936 John Deere broadcast binder, which was formerly owned by my paternal grandfather. My dad began to use it on his farm in 1941. Since he considered the binder part of his future inheritance from his dad, he cut his dad's hay crops as a courtesy. For several years during the forties, he also hired out his labor and the binder to custom-cut hay crops for other farmers in the area.

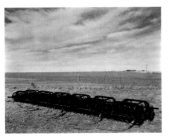

31

This John Deere, six-section, twenty-one-foot rotary hoe is one of the several implements that can be used to stop the dirt in the fields from blowing. It breaks the ground without pulling out the planted crop.

35

My dad owns two seed drills—a 1945 McCormick International with which he sows wheat only, and this 1936 Dempster three-section drill with which he sows either wheat or hay crops. Both are still in regular use.

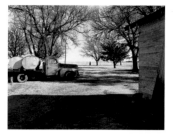

36

I used to drive this 1951 International truck loaded with wheat to the grain elevator during harvest time. It was almost new when I drove it, and I always thought it was pretty. I was driving the wheat trucks into town by the age of ten or eleven. We also used this truck for hauling wheat from the field to our own granaries on the farm. Now Dad uses it mostly for hauling water to a stock tank in another pasture where there is no well.

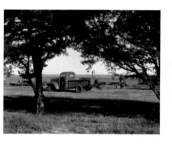

37

My dad carries fuel to his tractor in the field with a diesel tank loaded on the bed of the 1945 International. The cedar trees, planted in the early fifties, are the ones he dug up and brought back from my mom's family farm 400 miles to the east in Grayson County.

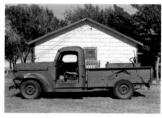

38

This is another view of the 1945 International pickup. My dad keeps it running but doesn't worry much about the cosmetics. For the seat, there's a piece of plywood on top of the bare metal springs and a tarp for upholstery. Last spring, a litter of kittens was born on the passenger side.

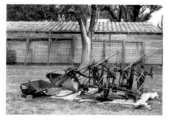

39

On the right is a two-row cultivator that Dad bought second-hand in 1952. To the left in the foreground is a dirt mover called a "Slip." If tractor-drawn, it required two men to operate, but if horse-drawn, it could be operated by one person who tied the lines from the horses together and put them over his shoulders, thereby enabling the use of both hands on the handles to load and unload the dirt. The curved blade behind the "Slip" shows one side of a walking plow, also horse-drawn.

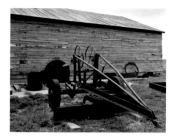

40

This road scraper, "Road Patrol #5," was originally outfitted with wheels in the front while being horse or mule-drawn, but it is now modified to be tractor-drawn. "Road Patrol #5" is owned by the county, is sometimes used by my father, but is available for anyone to use. It currently rests on the Creitz farm since the county has no particular place in which to store it.

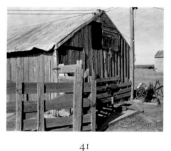

41

We always called this the saddle barn because it was a tack room, but it is attached to a longer structure that was a hog barn at the other end. Dad no longer has hogs on the farm and, with only one horse around, the space is now relegated to other storage, but it is still the "saddle barn." My brother made the branding iron heater that sits on the concrete pad in front of the door.

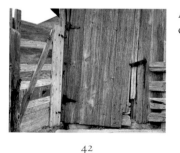

42

A detail of the saddle barn door and one of the corral gates.

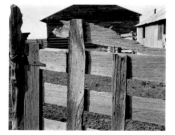

43

Many beautiful shapes evolve over the years on the gates and corral fences due to the effects of weather and of livestock rubbing on them. I was happily surprised to find that the top rail of the corral gate had finally produced this remarkable form after so many years. I photographed it as soon as I discovered it and decided I would photograph it again the next day in different light. When I returned and set my camera down at the desired spot, I was shocked to see that it had disappeared forever. The horse had leaned over it one more time, and, after all these years, it was broken and trampled into pieces.

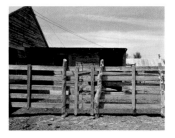

44

This short extension to the barn on the left was used for milking cows. It has a small pen that can be closed off to permit the segregating of livestock for various purposes.

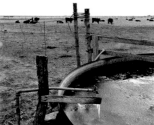

45

A winter view of the stock tank, milking barn, and feeder barn. When I was young, we often had algae-eating goldfish in the stock tank, and I recall many times climbing over these fences or sitting on the top rails to look at the livestock.

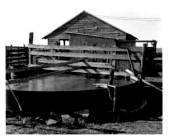

46

In winter, the stock tank often freezes over and tends to stay that way unless someone intervenes. Dad sunk a large barrel inside the stock tank where he burns scrap lumber in order to keep a portion of the ice melted, but first he breaks the ice with an ax and repeats the task as often as the low temperatures demand.

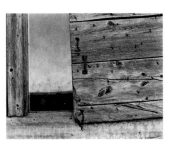

47

A detail of the milking barn gate and window.

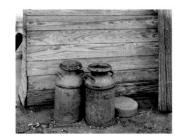

48

When Mom and Dad were first married, they had a half-dozen milk cows and sold the cream for income. They processed the fresh milk through a cream separator, poured the cream into five-gallon cans that had Dad's name etched on a plate on the outside, delivered it to the local train station, and shipped it to Colorado. It went on the Rock Island line to Amarillo, then switched to the Forth Worth and Denver line to go up to Trinidad, Colorado. The processor there would weigh and test the cream for the butterfat content and then ship the empty cans back by return train. A check would follow promptly in the mail. My dad said he always wondered what shape that cream was in by the time it got all the way to Trinidad.

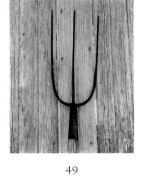

49

One of the older pitchforks. As the hay barns are now empty, the pitchfork gets used mostly for gathering tumbleweeds for burning.

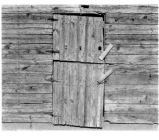

50

My dad built all of the barns, outbuildings, corrals, and fences on the farm. This is a detail from the west end of the feeder barn. Mom always said that, when Dad made anything, if one nail would do, he would use three.

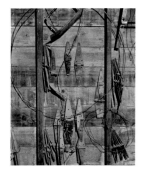

51

In the garage, which is part workshop and part shelter for the car and the later model pickup, Dad keeps all sorts of things—such as these hinges and the bailing wire—as he figures he "just might need them someday."

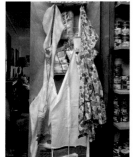

52

The apron on the right is made from a colorful polished cotton. As a teenager, I made a gathered skirt for myself out of this same material. Even aprons made from former garments and scraps of fabric were—and continue to be—made pretty and decorative.

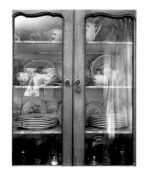

53

We had one set of really nice dishes—the fine china that was used when we had company for Sunday dinner or when we celebrated birthdays and anniversaries. We would open up the dining room table in the front room (part of the living room), adorn it with a fine handmade tablecloth, use the good china, silverware, and cloth napkins, and set out an abundant and wonderful meal.

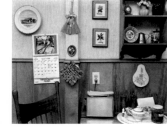

54

A detail of the kitchen table area. Mom did the crewel work in the wall plaques. Most of the other things are gifts from friends and neighbors, including the jar of pickles.

55

The kitchen windows look toward the south pasture and beyond to the neighboring farms. During our school years, we kept watch out these windows for the school bus before it arrived in front of our house. When we saw it turn onto the neighbor's road three miles away, we were able to finish breakfast, brush our teeth, grab our books, and get out to the road by the time it arrived.

During 1994 and 1995, my dad had operations on both knees, and, during the recovery times, walked with the aid of a cane. This counter became a convenient place on which to hang it.

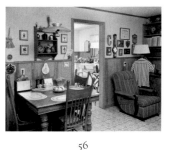

56

This view looks through the combined kitchen and sitting space into the utility room where Mom has her sewing corner along with the washer and dryer and ironing board. There is a large sink where Dad washes up after coming in from the field. To the right of the door is a wall of award plaques honoring my dad for his meritorious service to various organizations, such as the Boy Scouts of America, the Future Farmers of America, and the Agricultural Stabilization Conservation Service.

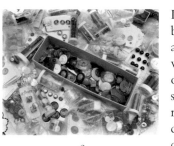

57

Mom taught me to sew at a young age on this old Singer. I remember wanting to learn so I could make clothes for my dolls. By the time I was in high school, I could make almost anything—from my prom dresses, including the matching long satin gloves, to finely tailored suits. I have since sewn miles of cloth for myself and my own family on a modern and much fancier machine. But that 1945 Singer still makes the smoothest and prettiest straight stitch I have ever seen.

58

I remember many of the garments from which these buttons came. Whenever we made clothes, it was always a treat to select the beautiful buttons that would finish them. And whenever something was outgrown or worn out, we cut off the buttons to save them for future use. The old garment was then relegated to its next use—a transformation into a different garment, patchwork for a quilt, a Christmas decoration, a pot holder, a dish towel, or maybe just a cleaning rag.

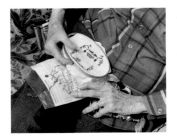

Almost every day, Mom works on one of her many counted cross stitch samplers. She makes three or four a month and gives many of them away as gifts. When she is not at work on an afghan or a quilt, she makes these samplers and other handwork items for a gift shop in Adrian that promotes tourism in the county.

59

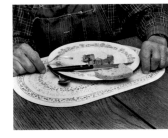

In the Panhandle, as in many rural areas, dinner is the midday meal. The evening meal is supper. For farmers and ranchers, both meals are necessarily substantial, not light.

63

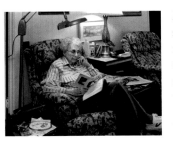

Mom is reading in "her spot." This easy chair also serves for sewing, conversing, TV watching, and napping. My parents are Methodists and use the small daily devotional guide, *The Upper Room*, as a supplement to their Bible study. Both of my parents taught Sunday School classes at their church for over thirty years; Mom taught the children's classes while Dad taught the adult classes.

60

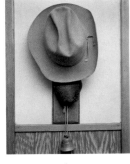

On a hook above a cow bell hangs one of Dad's "go-to-town" hats.

64

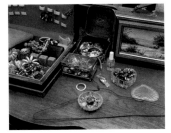

When I was a child, playing dress-up was one of my favorite pastimes. It included piling on glamorous selections of my mother's costume jewelry. She always seemed calm about it, but I've often wondered how many pieces I broke or lost.

61

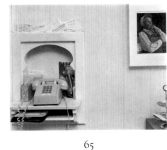

My parents got a telephone the first year they were married—a crank type. At that time there were six families on their party line, all connected to a switchboard in Adrian. Later, when they got a new rotary dial phone (one per household, basic black), there were still six different neighbors (we made seven) on the party line. We could always hear someone picking up his or her set to listen in, even though everyone pretended not to do this. Each person on the party line had a different signal designating whom the call was for so that everyone knew when to pick up the receiver. Of course everyone violated this in order to get or propagate the latest gossip.

65

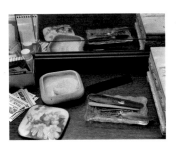

A detail of my parents' bedroom dresser.

62

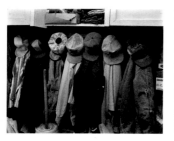

66

My dad has caps and jackets for a wide variety of uses and varying degrees of cleanliness or dressiness. He keeps them on hooks next to the back door along with some work gloves, boots, and a boot jack. Some of Dad's caps also hang on the wall above Mom's sewing corner. Farmers get lots of free caps—Dad currently has twenty-three. The old butter churn hasn't been used since the early fifties.

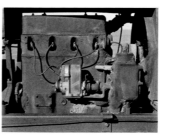

70

The 1927 Regular Farmall, a four-cylinder tractor, was made before the newer F20s and the larger and more powerful F30s. The 1927 tractor was originally owned by my paternal grandfather and is the oldest operating vehicle on the farm. My dad still uses it occasionally. It generally stays hooked up to a Continental post hole digger that was made around 1940.

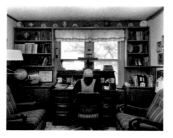

67

I have seen my father sitting in this spot so many times, quietly doing his accounting and paperwork. For over thirty years, he donated his time to be treasurer for their church. I remember him sitting at this desk doing the accounting for the church each Sunday after we got home from services.

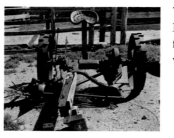

71

The "John Deere No. 4" is a six-foot sickle mower. Bought by my paternal grandfather in 1935, it was first pulled by horses before he converted it for use with tractors.

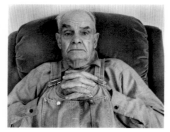

68

I asked my father, "If you had it to do all over again, what would you do differently?" After a long and reflective pause, he replied, "Not a thing."

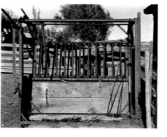

72

The branding and dehorning chute is used for just what it says it is. Dad's brand was an L for his first name, Lorin, so it would have been easy to add a line or curve to change it to another brand should someone have wanted to steal some of Dad's cattle. But my dad never had any of his cattle rustled, so he kept the brand simple.

When it came time for branding and dehorning, I would hang over the corral fence and watch. The cattle certainly didn't like it, but I remember Dad assuring me that it didn't hurt them much.

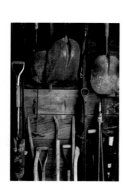

69

Shovels and other tools are arranged on a wall inside the garage. The large flat shovel is a grain scoop.

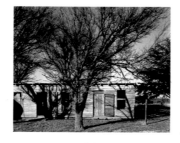

73

The chicken house is now a repository for equipment and spare parts, and a haven for dozens of farm cats that come and go. As a child, I helped feed the chickens and collect the eggs, though I seldom gathered them all by myself. I just couldn't get the knack of putting my hand under laying hens without getting pecked—Dad said I didn't talk to them right.

Each spring, we brought home baby chicks that Dad had ordered from various hatcheries. They were shipped by train to the local post office. Once we got them settled in their new home, it was always an exquisite pleasure to get inside the brooder pen and hold the soft and downy chicks, letting them crawl over and tickle me with their nearly weightless bodies.

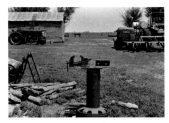

The piece of equipment in the foreground was made by my brother. It is a combination vise and anvil with a piece of train rail as the anvil. Both are mounted on an eight-inch column of pipe with a truck rim for a base.

74

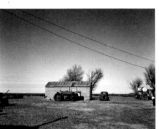

The 1946 Farmall H tractor, the 1955 International 400 tractor, and my grandfather's 1945 International pickup are all kept in good operating condition. The granary now stores other things as the yearly harvest goes entirely into the Adrian Wheat Growers Grain Elevator, seen on the horizon, three miles away as the crow flies.

75

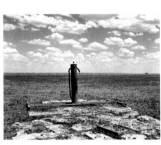

This cow scratcher goes by the brand name "Old Scratch" and was manufactured by a company in Amarillo. Although it is now broken, cables on two sides that were surrounded by steel washers extended and attached to the ends of the base so that cattle could walk under it, rub, and scratch their hides as they are wont to do—and this motion activated the oiler in the center column. During this pleasurable process, the cattle got the added benefit of a good oiling, protecting their hides from lice and other pests.

76

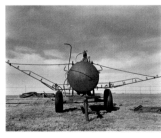

The weed sprayer, circa 1949, has been retired for almost twenty years. It was replaced by the more convenient method of aerial spraying. On the rare occasion when there is too much rain in the spring, the weeds can grow stronger and faster than the wheat and choke out the crop. Before weed sprayers were invented, farmers could not protect their crops from bind weed and other voracious invaders. Whenever possible, Dad kills the weeds by plowing them under, but once a crop is intermingled with them, spraying is needed.

77

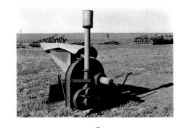

No longer in use, the head of this feed grinder is from the mid-1940s. My dad used it to grind grain for the hogs and chickens and ceased to use the grinder after he quit the hog and chicken business in the mid-1970s.

78

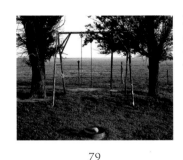

Looking toward the south pasture. The homemade swing has been in a variety of places in the back yard. When I was a child, we often had a hammock between the two elm trees.

79

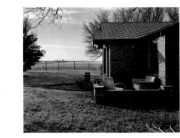

The house faces due east, and the porch furniture has served for thousands of hours as a place in which to watch the birds, the rabbits, the stars—and to savor the soft sounds and rosy light of evening. There were many times in the summer when Mom sat on the porch swing to shell peas and beans, fresh-picked from the garden. My parents often still sit there to talk.

80

The photographs for *High Plains Farm* were made between December of 1994 and April of 1996
on five separate visits. All are silver chloride contact prints made with an 8 x 10-inch view camera.
The 5 x 7-inch photographs were made with a reducing back on the 8 x 10 camera.

Designed by P.M. Design Studios
Typeset in Monotype Centaur and Monotype Bembo
and printed on 65-pound cover Quintessence
from laser-scanned Fultone™ negatives
by Gardner Lithograph
Bound by Roswell Bookbinding

This book has been printed in a regular hardcover edition of 2,750
and a signed and numbered Special Limited Edition of 250

For information regarding the availability of the photographs:
Paula Chamlee P.O. Box 400 Ottsville, Pennsylvania 18942
610–847–2005